PANEL THREE:
COMIC BOOK SCRIPTS BY TOP WRITERS

PANEL THREE:

COMIC BOOK SCRIPTS BY TOP WRITERS

Edited by Nat Gertler

About Comics | Camarillo, California USA

Panel Three: Comics Book Scripts by Top Writers
Copyright 2021 About Comics

Jack Ooze © Lowell Cunningham
Potter's Field © Mark Waid
Banned Book Club © Kim Hyun Sook & Ryan Estrada
Cherubs! © Bryan Talbot
The American © Mark Verheiden
The Burning Metronome © R. Alan Brooks
The Dire Days of Willowweep Manor © Shaenon Garrity
Eccentric Orbit © Barbara Randall Kesel
Age of Bronze copyright © 2021 Eric Shanower. All rights reserved.

Paperback edition ISBN 978-1-949996-39-5

Continuous printing beginning November 2021

For wholesale or bulk orders, customized editions,
and all other inquries: questions@aboutcomics.com

CONTENTS

FOREWORD

The most important thing to remember about comic book scripts like the ones that you see in this book is that you were not meant to see them. A comic book script has a central intended audience of one person: the artist who is going to "pencil" the story. Sure, other people will likely see it, such as an editor who reviews the work before passing it on to the artist, or the letterer who will need to take the dialogue and captions described and put them on the page. But its main goal is to get an artist to understand the story that's in the writer's mind, and the basics of how it's to be told.

That doesn't mean that the art that appears on the page is supposed to look exactly like how it was in the writer's head. Artists bring their own creativity into the telling of the story, building on what the writer has provided. An artist who can't understand what you're trying to do, however, can't bring you the art that serves and enhances it.

In this book you'll find a variety of scripts. These were created under different circumstances, whether it is someone who is solely a writer and is used to always working with an artist, or a cartoonist who is writing a script for a work they'll draw themselves, or even someone used to doing all the work who is instead writing a script for a collaboration. The writers of these scripts represent everything from newcomers with a handful of issues to their credit to those with several decades of experience in the field. They come from a range of backgrounds and influences, but all have found their spot in the special medium of comics.

You'll see a lot in common in these various scripts, but a lot of differences as well. There are differences in formatting, yes – unlike scripts for film and theater, there is no established standard to follow – but also differences in attitude, in how much needs to be put in the script, with what sort of emphasis. There are no fixed rules; whatever the writer feels works, that will do.

So if you want to write comics, look at these scripts as toolboxes. You may want to swipe the way someone describes the panel, the way someone else formats their dialog, and that one helpful little editorial note, and put them in your own toolbox. You might never use every tool you have stored, but when the right opportunity hits in the right kind of script, they'll be there for you, ready to help make your script the powerful, useful thing it was meant to be.

–Nat Gertler
November, 2021

KIM HYUN SOOK & RYAN ESTRADA

I've never written two scripts the same way.

I've been making comics since I was a baby, and started submitting strips to newspapers in 1986, when I was six years old. Depending on the needs of the project, I can use different formatting, different software, and different amounts of information. Sometimes I draw and publish comics myself, in which case my scripts are just bits of dialogue in a blank email because I know my head will fill in the rest. Sometimes I work with a publisher, in which case I've got to pretty it up and make sure my editor has the same visual image in their heads that I do. Sometimes I work with an artist, which means I have to talk to them about the format that works best for them.

When I worked with Axur Eneas on Student Ambassador: The Missing Dragon, figuring out the visual design and panel breakup was the part he was most excited about. So I just broke my script up into pages, and included only actions and dialogue, letting him figure out the rest. On Banned Book Club, I was working with Ko Hyung-Ju, an artist who spoke English as a second language. So in order to be sure he didn't have trouble understanding anything, we had a lot of discussions about how best to format. I broke it down visually as much as I could, without using any language that was too complicated

After many decades of writing scripts completely on my own, this one became a massive collaboration that involved many, many people. What you're seeing here is a final draft that had many, many hands on it. It was co-written with my wife Kim Hyun Sook, who actually lived through the experiences depicted. She would tell me her stories verbally, and I would combine them into a story, then break them up into pages and panels. She would then read it and suggest changes. We then shared the pages with dozens of people who lived through the experiences depicted. Former student activists and teachers, and the real banned book club members that the characters were based on. Our editors, Spike Trotman and Andrea Purcell at Iron Circus Comics then looked at it from an outside perspective, making sure it made sense to someone learning about this history for the first

time. Finally, Hyung Ju brought his own visual ideas and changed the way the panels were broken up and executed to match his own style.

This project also had an interesting second half, because the book had a simultaneous release in both English and Korean. So after the script was locked in English, Hyun Sook had to translate it back into Korean. We then switched places, so that it was her at the computer, and me in the chair answering questions about the meanings of various bits of wordplay in the script.

This script was written in Celtx, a scriptwriting software I used to use for everything, until they made the version I bought obsolete and made it subscription-based. Now I use it only occasionally, since I'm on a free plan and it makes me delete an old script in order to start a new one. It has a "comic book script" option, but I find it bizarre and useless, so I just write in "screenplay" format and use the shot transitions to include page and panel numbers. I often use Google Docs instead and format by hand, or just go back to composing in a good old blank email.

– Ryan Estrada
November, 2021

PAGES 16-17 - PANEL 1

We are now in the middle of a Talchum dance. Multiple characters in different traditional Korean masks dance a pantomime. In the center is a Yangban (a nobleman) who we will learn later is Yuni. To the side is a Yongno, a giant lion-headed monster costume operated by two people. In a circle, the drummers (including Hyun Sook, Suji, Gundo and Jae-Young) are playing along to the show.

PANELS 2-3

For the rest of this one, you can just draw different angles of the traditional dance. It's up to you! This will be the first time many readers see a Korean folk dance so make it beautiful! Show the dancers, the hanboks, the masks, the drums, etc!

PAGE 18 - PANELS 1-3

A series of different angles, where we can more clearly see Hyun Sook performing. She has a big smile. Everyone is having a blast.

SFX
BUM BUM BUM... BUM **BADA-BUM!**

PANEL 4

An angry, stuffy, fellow student named Myungja shouts out a second story window as flags and confetti wave in front. Hyun Sook is taken aback, and this has taken a little of the fun out of it.

MYUNGJA
Will you **shut up?** Some of us want to study!

PAGE 19 - PANEL 1

The emcee of the performance, Hoon, rolls with the interruption, and makes it part of the show. He looks up and addresses Myungja, but plays to the crowd.

HOON
It sounds like we have a fan of live theater!

PANEL 2

Hoon now speaks directly to the assembled audience of college students.

> HOON
> How about a nice round of applause for
> our newest members? They too have been
> studying hard all week!

PANEL 3

Hoon points to the performers who have now assembled on a makeshift stage.

> HOON
> Ladies and gentlemen, now gather round
> as the Anjeon University Masked Dance
> Team performs the 900-year-old folk
> tale.. Yeongno and the Yangban.

PANEL 4

Yuni, in the Yangban costume, now suddenly and dramatically steps out onto the stage holding a paper fan.

> HOON
> It's the story of a hero who slays a
> monster!

PAGE 20- PANELS 1-3

Yuni is now dancing, wearing a wooden mask of an old man, a tall hat, and a hanbok.

> SFX
> DA DUM... BAM BUM

PANEL 4

We see a closeup of Hyun Sook and Suji, who are happily doing the drumming, whispering to one another while watching Yuni's performance.

> HYUN SOOK
> She dances so beautifully as the hero.

> SUJI
> Beautiful, yes. But she's not the
> hero.

PAGE 21 - PANEL 1

Suddenly a dancer dressed as Yeongno, the giant lion-monster, bursts dramatically onto the stage. The costume is huge. (we will learn later that it is operated by Hoon) Yuni, dressed as the Yangban, pretends to shiver in fear.

> MONSTER
> RRRRRAAAAAAAARRRRRR!!!

PANEL 2

> MONSTER
> I will eat you, Yangban!

> YUNI
> I am just a simple man!

PANEL 3

The dance continues. The nobleman rubs his face in fear.

> MONSTER
> **Liar!** I know the smell of a Yangban! I
> have eaten 99!

> YUNI
> I will wash off the smell!

PANEL 4

As the monster looms threateningly, the nobleman tears off his robes.

> MONSTER
> If I eat **one more**, I can get into
> heaven! And you wear the **clothes** of a
> Yangban!

> YUNI
> Then I will take them off! Spare me
> and I will give treasures beyond your
> **wildest dreams!**

PAGE 22 - PANEL 1

> MONSTER
> Would you really?

 YUNI
 I will give you **anything**! Gold!
 Rubies! **Diamonds!**

 PANEL 2

 MONSTER
 Then it's settled! Only **a Yangban**
 would have such riches to spare!

 PANEL 3

The monster lurches forward, pretending to eat Yuni. She
disappears inside the monster costume.

 YUNI
 AAAHHHHH!!!

 PANEL 4

Everyone stands up and follows the dancers around the same
area where they protested before. Many of the crowd are now
wearing bandanas to hide their faces. It is becoming a
protest. Hyun Sook looks confused.

 PROTESTORS
 (chanting)
 President Chun! Step down! **Step Down!**
 President Chun! Step down! **Step Down!**

 PAGE 23 - PANEL 1

Hyun Soon turns to Yuni, who is now crawling back out of the
Yeongno costume.

 HYUN SOOK
 Huh? Why are they **protesting** during
 our show?

 PANEL 2

Yuni, still wearing the mask, pokes her head out of the
monster's bum.

 YUNI
 They're protestors. And... we miiight
 have coordinated schedules with them.

 PANEL 3

Hyun Sook is confused, and surrounded by chanting protestors.

 PROTESTORS
 (chanting)
 President Chun! Step down! **Step Down!**

 HYUN SOOK
 What? Why?

 YUNI
 Activists need entertainment too!

 PANEL 4

Hyun Sook is starting to look panicked.

 HYUN SOOK
 I joined this team to **stay out** of
 politics!

 PANEL 5

Yuni starts to remove the mask.

 YUNI
 In times like this, **no act** is
 apolitical.

 PANEL 6

Hyun Sook is perplexed.

 HYUN SOOK
 Not even a monster dance?

 PAGE 24 - PANEL 1

Yuni has removed the mask, and we see her face for the first
time.

 YUNI
 A monster who **eats Yangban**. You do
 know what a Yangban is, right?

 PANEL 2

 HYUN SOOK
 Um...

 YUNI
 A politician. Can't get much more
 political than that.

 PANEL 3

 HYUN SOOK
 It's 900 years old!

 PANEL 4

A wide panel. Hoon, now wearing the Yeongno costume, pokes
his head out of the monster's mouth. Hyun Sook is now talking
to people popping their heads out of both sides of the
monster.

 HOON
 I guess we'd better protest harder,
 because we still have all the same
 problems.

 HYUN SOOK
 Did you do that entire dance just to
 push people to want to fight
 politicians?

 YUNI
 Oh, no. Your loud drumming is enough
 to get them riled up for that.

 PAGE 25 - PANEL 1

Yuni removes the Yangban costume and yells back to Hyun Sook
as she runs off to join the protest.

 YUNI
 The rest is just **showmanship.**

 PANEL 2

As Hyun Sook watches Yuni run away, Hoon speaks to her.

 HOON
 Hey, sorry. We didn't mean to take you
 by surprise. It's just that's why
 these dances were invented, to protest
 ancient Confucian noblemen.

 PANEL 3

 HYUN SOOK
 I just... I came here to **study**, you
 know? I have nothing to protest about.

 HOON
 I get it. You want to **learn** some
 things.

 PANEL 4

Hyun Sook starts gathering her things. As she picks up her
backpack, Hoon notices that it is overflowing with books.

 HOON
 It's Hyun Sook, right?

 HYUN SOOK
 Yeah.

 PANEL 5

 HOON
 Hey Hyun Sook. Do you uh, Do you like
 books?

 PAGE 26 - PANEL 1

Hyun Sook is in her bedroom. She's standing in front of a
mirror trying on an outfit. She has a different blouse, still
on the hanger, in her hand.

 PANEL 2

Mom pops in.

 MOM
 You're not working in the restaurant
 tonight? I thought you didn't have
 class!

 HYUN SOOK
 I was invited to a book club!

 PANEL 3

Hyun Sook holds up the other blouse to see which she prefers.

 MOM
 I let you have time off for **studying**,
 not to hang out in **clubs**!

 PANEL 4

Hyun Sook holds up a few of her favorite books, deciding
which ones to bring. She holds The Scarlet Letter, Hamlet,
and Moby Dick.

 HYUN SOOK
 Book club, mom, not **night club!**

 PANEL 5

Hyun Sook stuffs all three books in her backpack.

 HYUN SOOK
 I'm a literature major! It **is**
 studying.

 PAGE 27 - PANEL 1

Hyun Sook sits on a bus, looking at a scrap of paper with an
address written in Korean.

 PANEL 2

Hyun Sook walks up a creepy old stairwell, with her backpack
on her back, and still holding the paper.

 PANEL 3

Hyun Sook nervously knocks on the door.

 PANEL 4

The door opens just a little bit, with the chain still
connected. Suji peeks out suspiciously.

 SUJI
 Who are you?

 HYUN SOOK
 I, uh--

 PANEL 5

Hoon swings the door wide open, smiling.

 HOON
 Hyun Sook! You made it!

 HYUN SOOK
 Hi!

 PANEL 6

Hyun Sook walks into the room.

 HOON
 Come on in, I'll introduce you!

 SUJI
 Take your shoes off! My mom will kill
 me if anyone tracks in mud.

 PAGE 28 - PANEL 1

Each introduction is treated like a title card. The
characters are depicted, holding their books, next to the
word bubble listing their stats.

We see Hyun Sook standing in front of everyone and waving
awkwardly.

 HOON
 Everyone, meet **Hyun Sook.**

 Freshman. English Language &
 Literature.

 Extracurriculars: Undecided.

 HYUN SOOK
 I brought The Scarlet Letter, by
 Nathaniel Hawthorne.

 PANEL 2

We see Hoon himself, standing like a leader.

 HOON
 I'm **Hoon.**

 Sophomore. Law.

 Extracurriculars: Editor, school
 newspaper. Mask Dance Club.

> HOON
> I'm rereading The Motorcycle Diaries,
> by Che Gueverra.

PANEL 3

Yuni leans against the wall in a bad-ass pose.

> HOON
> You know **Yuni**.
>
> Senior. Department of Psychology.
>
> Extracurriculars: President, Women's
> Student Council. Mask Dance Club.

> YUNI
> I'm in the middle of Counter-
> Revolutionary Violence: Bloodbaths in
> Fact & Propaganda by Noam Chomsky.

Hyun Sook looks a little concerned.

> HYUN SOOK
> Bloodbaths?

PAGE 29 - PANEL 1

Gundo is sitting in the sofa, with rumpled, dirty work
clothes.

> HOON
> This is **Gundo**.
>
> Senior. Department of Economics.
>
> Extracurriculars: Works undercover
> part-time in a factory to start a
> whisper-campaign about unions.

> GUNDO
> I brought Pedagogy of the Oppressed,
> by Paulo Freire.

Hyun Sook has a little look of surprise.

> HYUN SOOK
> I think I recognize you from
> somewhere...

PANEL 2

Suji is sitting on the floor, calm, looking like she is meditating.

> HOON
> That's **Suji.**
>
> Junior. Mathematics Department.
>
> Extracurriculars: vice-chair, Anjeon
> Feminist Association. Loves punching
> cops.
>
> SUJI
> I got The Feminine Mystique, by Betty
> Friedan.

Hyun Sook looks freaked out.

> HYUN SOOK
> Sorry, did you say... punching cops?

 PANEL 3

Jihoo is sitting on the sofa, innocently eating the snacks.

> HOON
> And finally, **Jihoo.**
>
> Sophomore. Creative Writing Program.
>
> Extracurriculars: Poetry Club,
> Pacifist Coalition.
>
> JIHOO
> Oh hi! You guys ever read Cry of The
> People and Other Poems, by Kim Ji-ha??
> It's real good!

Hyun Sook is starting to freak out

> HYUN SOOK
> I saw some masked people punching cops
> the other day, that wasn't...

 PAGE 30 - PANEL 1

> YUNI
> So we've been discussing Rhee Young-
> Hee's *Logic For An Era of Transition.*
> And the thing I kept coming back to...

PANEL 2

Hoon leans over and hands Hyun Sook some printouts. Hyun Sook looks panicked.

 HYUN SOOK
 I don't have a copy of--

 HOON
 (whispering)
 I made you some copies of the chapter
 we're reading. If you want to read
 ahead, I wrote the address to a
 bookstore that has one more copy.

PANEL 3

 YUNI
 Hoon, will you stop writing down
 addresses? You're going to get someone
 arrested.

PANEL 4

 HOON
 Sorry.

 HYUN SOOK
 Arrested??

PAGE 31 - PANEL 1

 YUNI
 So anyway, it reminded me of how much
 the **"Bread and Circuses"** idea of
 ancient Rome ties directly into the
 current regime's **3S Policy**.

 HYUN SOOK
 Wait what....

PANEL 2

Hyun Sook picks up a book from the table. It is *What Is History?* by EH Carr.

 SUJI
 It stands for sex, sports and screen.

 HYUN SOOK
 But why---

 PANEL 3

 JIHOO
 The government thinks they can keep us
 quiet with entertainment.

 PANEL 4

 GUNDO
 People mad they can't gather in
 public? Bring the Olympics so they can
 gather to cheer for their country by
 the thousands!

 PANEL 5

Hyun Sook looks panicked, and is trying to make sense out of
all this.

 HYUN SOOK
 But I mean--

 PANEL 6

 SUJI
 Filmmakers complain that you're
 limiting their political speech? Lower
 the regulations on on-screen nudity
 instead!

 PANEL 7

 YUNI
 That's why the #1 film in the country
 is about a **naked lady riding a horse.**

 HYUN SOOK
 Wait--

 PANEL 8

 GUNDO
 You can't really see anything.

 PANEL 9

Yuni glares at Gundo.

PAGE 32 - PANEL 1

Hyun Sook stands up, throws up her arms and shouts to get everyone's attention. The EH Carr book is in her hands.

> HYUN SOOK
> **Why would we get arrested???**

PANEL 2

Yuni looks at Hoon, disappointed. He grins awkwardly

PANEL 3

Yuni facepalms.

> YUNI
> Hoon, did you not tell her what kind
> of club this is?

PANEL 4

Hoon turns to Hyun Sook.

> HOON
> These books are... uh, *technically*
> banned.

PANEL 5

Hyun Sook freezes in place, looking shocked and terrified. Her eyes are wide with fear

> HYUN SOOK
> Banned?

> HOON
> Banned.

PAGE 33 - PANEL 1

> HYUN SOOK
> You mean like that banned book club
> that went to **prison?**

15.

 HOON
Oh no, that wasn't a banned book club.
The government trumped up those
charges for political gain. It was
just poor students sharing textbooks
to save money.

 PANEL 2

Hyun Sook still looks scared. Yuni looks nervously at Hoon.

 HYUN SOOK
Is that what this is?

 YUNI
No. This is an actual banned book
club.

 PANEL 3

Hoon is unfased, and just looks excited to share information.

 HOON
That book in your hands is the one
they got arrested for!

 PANEL 4

Hyun Sook drops the EH Carr book and is frozen in the middle
of the room, surrounded by illegal books. The book makes a
"thud" sound.

 PANEL 5

Hyun Sook is horrified.

 HYUN SOOK
I... have to go.

 PAGE 34 - PANEL 1

As Hyun Sook heads to the door, Hoon grabs her arm.

 HOON
I'm sorry. Look, just stick around and
we'll--

 PANEL 2

Hyun Sook pushes away his arm.

 HYUN SOOK
You want me to lose my **scholarship?** I
don't want to get kicked out of school
in the **first week!**

 PANEL 3

Hyun Sook is panicking, thinking of all the scary things that
could happen.

 HYUN SOOK
Or let my dad down! Or prove my mom
right!

 PANEL 4

Closer on Hyun Sook's face

 HYUN SOOK
Or go to **jail!** And for **what?** To break
the rules and be **cool?**

 PANEL 5

Yuni steps between Hyun Sook and Hoon. She gives Hoon a dirty
look.

 YUNI
Hyun Sook, I'm sorry that Hoon didn't
tell you what this was. That was not
okay, and you have every right to be
upset.

 PAGE 35 - PANEL 1

Yuni turns to Hyun Sook.

 YUNI
But if You really think this is all
about being cool, then you have some
waking up to do.

 PANEL 2

Yuni puts a hand on Hyun Sook's arm.

 YUNI
And if you ever need help with that,
you know where to find us.

 PANEL 3

Hyun Sook is in the street outside the apartment building.
She is bent over, grabbing her knees and trying to catch her
breath.

PAGE 36 - PANEL 1

A police car passes by Hyun Sook in the street. Her eyes pop
open wide with fear.

PANEL 2

Hyun Sook stands up and looks over her shoulder as the police
car drives away. She looks terrified and paranoid.

PANEL 3

Hyun Sook runs away.

PANEL 4

Back inside, the club members have continued their
conversation. Yuni rolls her eyes at Gundo

 YUNI
 Of course you watched the naked horse-
 lady movie.

 GUNDO
 I watched it with **Suji!**

PANEL 5

Suji gives a faint smile.

 SUJI
 Look, it's a good movie.

Mark Waid started in the comics field as a writer of fan magazines. He moved on to writing comics, then editing comics, then became an editor-in-chief. He has earned a place as one of the most respected creators in the traditional comics mainstream, including an eight year run as writer of **The Flash**, a reworking of **Archie**, and work on almost every major superhero character. His take on an alternate superhero future, **Kingdom Come**, is among the bestselling superhero comics of all time. He has won Eisner and Harvey Awards, launched an original webcomics site, and found a variety of ways to share his knowledge with young and aspiring comics creators... including offering a script in this volume.

The script is for the first issue of **Potter's Field**, an original crime series. In it, you can see not only see Mark's skill – using sparse descriptors to allow the artist room to run but adding detail when he needs to make sure the artist is aware of the panel's intent – but some very useful mechanical steps that he has adopted along the way. Being sure to put "((more))" at the bottom of a page of script where the page description continues to a second page, for example, avoids situations where the artist fills the page with what's on that first page of script, and only then discovers the error.

–Nat Gertler

POTTER'S FIELD #1
Script for 22 pages
Mark Waid
First Draft/August 31, 2006

PAGE ONE

FULL-PAGE SPLASH: TIGHT ON THE FACE AND HEAD OF A SOUTH AMERICAN BOY IN HIS EARLY TWENTIES--EXCEPT HIS FEATURES ARE SOMEWHAT OBSCURED BECAUSE, REACHING AROUND FROM BEHIND HIM, TWO BIG-BRUTE HANDS ARE PULLING A TRANSLUCENT PLASTIC BAG TIGHT ACROSS HIS FACE, SUFFOCATING HIM. THE KID IS WIDE-MOUTHED, FRENZIED, CLUTCHING USELESSLY AT THE BAG. WE DON'T NEED TO SEE ANY DETAILS ON HIS EXECUTIONER.

FYI, THIS IS GOING TO BE OUR FIRST-PAGE MOTIF THROUGHOUT--OPENING EACH ISSUE WITH A SHOT OF A VICTIM, BUT SEEN IN SUCH A WAY THAT WE CAN'T REALLY MAKE OUT THEIR FACE CLEARLY (FOR INSTANCE, NEXT ISSUE OPENS WITH A MIRROR CRACKED SO THAT WE SEE ONLY FRAGMENTS OF THE FACE THAT'S JUST BEEN SMASHED INTO IT).

1 CAPTION: "Marker 36905 belongs to a drug mule who wanted out.

2 CAPTION: "He got his wish."

PAGE TWO

PANEL ONE: NIGHT, A FILTHY NEW YORK ALLEYWAY IN CHINATOWN. COPS WITH FLASHLIGHTS FIND THE KID'S CORPSE, HIS HEAD STILL SLOPPILY WRAPPED IN PLASTIC. IMPORTANT--THERE NEEDS TO BE IN THIS SHOT SOME DISTINGUISHING MARKER, LIKE A DUMPSTER WITH A SPECIFIC PIECE OF GRAFFITI ON IT OR AN OLD, WEATHERED SIGN ON AN ALLEY DOOR THAT SAYS "PAGODA RESTAURANT," OR SOMESUCH.

1 CAPTION: "New York's finest found his body behind a
 restaurant on CANAL STREET.

2 CAPTION: "No ID, no prints on file, no match to any
 missing persons report. Crime victim, obviously,
 but zero leads.

PANEL TWO: TIGHT ON THE VICTIM'S FEET AS HE LIES ON A MORGUE SLAB. THE SHEET OVER THE BODY IS TURNED UP JUST ENOUGH TO REVEAL ONE FOOT, AND A CORONER'S RUBBER-GLOVED HANDS REACHES INTO THE SHOT, AFFIXING A TOE TAG THAT READS "36905" AND "UNIDENTIFIED."

3 CAPTION: "Meaning once the NYPD did all the investigating
 it had the manpower to do, drug mule ended up
 where all the city's faceless dead end up.

PANEL THREE: ESTABLISHING SHOT OF THE POTTER'S FIELD SIGN-ARCH AGAINST AN OVERCAST SKY (SEE REFERENCE).

4 CAPTION: "There's a cemetery on Hart Island at the western
 end of Long Island Sound.

5 CAPTION: "Unidentified corpses are buried here under plain
 stone markers at the rate of around 125 a week.

6 CAPTION: "(It's a big city.)

((more))

PAGE TWO, continued

PANEL FOUR: ESTABLISHING SHOT OF THE GRAVEYARD. WE'RE GONNA PLAY A LITTLE FAST AND LOOSE HERE, PAUL--IN REALITY, AS YOU CAN SEE IN THE REFERENCE, THERE ARE ACTUALLY SEVERAL DOZEN CORPSES PER MARKER, AND THE MARKERS ARE CROSSES, NOT HEADSTONES, BUT WE'RE GOING TO TAKE SOME ARTISTIC LIBERTIES. BASICALLY, FOLLOW WHAT DEREC ESTABLISHED IN THE FIVE-PAGER FOR THE GENERAL LOOK WE WANT--A VAST FIELD OF FLAT MARKERS LIKE THE ONE YOU RENDERED ON THE PREVIEW COVER.

7 CAPTION: "About two-thirds of these are infants and
 stillborn, but that still leaves a whole hell of
 a lot of folks who die under a cloud of mystery."

PAGE THREE

<u>PANEL ONE</u>: TIGHT ON A PLAIN MARKER NUMBERED 36905, AS SEEN PAST JOHN DOE'S FOOT/LEG IN THE SHOT.

1 CAPTION: "People denied any MOURNING by their ANONYMITY.

<u>PANEL TWO</u>: REVERSE ANGLE, TIGHT ON JOHN DOE'S FACE, TIGHT ENOUGH TO READ THE NUMBERS IN REVERSE IN HIS MIRRORED SHADES.

2 CAPTION: "And that bugs the holy living hell out of this guy.

<u>PANEL THREE</u>: BACK IN THAT SAME ALLEYWAY FROM PAGE TWO, PANEL ONE--WE CAN TELL WE'RE THERE BECAUSE OF WHATEVER DISTINCTIVE THING YOU USED TO MARK IT IN THAT PANEL. HERE, JOHN DOE (HEAVILY SHADOWED) IS SLIPPING MONEY TO A HOMELESS GUY WHO'S TELLING HIM SOMETHING.

3 CAPTION: "He knows tricks that can set a cold case on FIRE.

4 CAPTION: "He talks to informants who'll listen only to HIM.

<u>PANEL FOUR</u>: ESTABLISHING SHOT, A FENCED MANSION IN THE 'BURBS-- GUARDS, GUARD DOGS, RAZOR WIRE, THE WORKS--AN OPULENT PLACE, BUT IT JUST SCREAMS DRUG LORD.

5 CAPTION: "He goes places the police can't."

PAGE FOUR

PANEL ONE: CLOSE-UP ON A FAT MOBSTER'S FACE UNDERWATER, WIDE-EYED, DROWNING--WE'RE LOOKING STRAIGHT-ON AT HIM AS DOE (OFF-PANEL) HOLDS HIS HEAD IN A TOILET.

1 CAPTION: "And he never rests until he can give the dead
 the only thing he can:

PANEL TWO: A MOMENT LATER. THE MOBSTER, IN A BATHROBE, SITS NEXT TO THE TOILET, COUGHING, HIS HEAD SOAKING WET. NEARBY, JOHN (AGAIN, HEAVILY SHADOWED--WE'RE SAVING HIS BIG REVEAL FOR NEXT PAGE) HAS TURNED UP A CORNER OF A THROW RUG ON THE FLOOR AND IS PULLING A CLEAR PLASTIC BAG FULL OF U.S. PASSPORTS FROM A HIDDEN FLOOR SAFE.

PANEL THREE: OVER JOHN'S SHOULDER, WE SEE AN OPEN PASSPORT. (IN BACKGROUND, LYING SCATTERED ON THE FLOOR, IS A PILE OF CLOSED PASSPORTS.) THE WAY HE'S HOLDING IT, HIS HAND OBSCURES THE NAME (OR MOST OF IT, EXCEPT FOR MAYBE A FEW LETTERS), BUT WE CAN CLEARLY SEE THE PHOTO. IT'S THE DRUG MULE.

PANEL FOUR: TIGHT ON JOHN'S HANDS CARVING THE NAME "ALEJANDRO RUIZ" INTO HEADSTONE 36905.

2 CAPTION: "A name to be REMEMBERED by."

PAGE FIVE

PANEL ONE: A MINUTE LATER, JOHN STANDS OVER THE MARKED GRAVE. A PEN ALREADY IN HAND, HE TAKES HIS LITTLE NOTEBOOK OUT OF HIS POCKET--

PANEL TWO: --AND WE'RE TIGHT ON A PAGE WITH THE FOLLOWING LIST OF NAMES AND NUMBERS. ALL THE ONES INCLUDING ALEJANDRO'S ARE CROSSED OUT WITH ONE LINE THROUGH THEM, AND HERE HE'S ADDING THE NUMBER 36906 TO THE LIST.

1 LIST: 36901 Mary Beatty
 36902 Joseph Lee Cardin
 36903 Tashana Brown
 36904 Michael Nelson
 36905 Alejandro Ruiz

PANEL THREE: TIGHT ON MARKER 36906 AS JOHN'S FOOT STEPS PAST IT.

PANEL FOUR: JOHN EXITS THE GRAVEYARD.

2 CAPTION: "Who is this guy? Beats me. I've been working for
 him for three years, and he's never SAID.

PANEL FIVE, BIG: A NICE UP-SHOT OF JOHN DOE, OUR FIRST REALLY GOOD, SUPER-CLEAR LOOK AT HIM.

3 CAPTION: "I call him JOHN DOE."

PAGE SIX

PANEL ONE: CUT TO A MAN'S WALLET, KEYS, AND PHOTO-I.D. BADGE ON A NIGHTSTAND.

1 BADGE: HART ISLAND PENITENTIARY
 JORDAN HALPERT
 NY DEPT OF CORRECTION
 SECURITY

2 FROM OFF: I thought you worked at the PRISON.

PANEL TWO: PULL BACK SO WE CAN SEE THAT WE'RE IN A BEDROOM. A STOCKY MAN (THE ONE PICTURED ON THE I.D. BADGE) IS IN BED WITH AN ATTRACTIVE WOMAN. CLOTHES ARE STREWN AROUND, HIS AND HERS ALIKE; THEY'VE CLEARLY BEEN GOING AT IT. A SMALL PORTABLE TV IS ON, BUT THEY'RE NOT REALLY PAYING ATTENTION TO IT.

3 HALPERT: Officially, yeah. I don't really mean "work for
 him." It's not like there's MEDICAL or DENTAL.

4 HALPERT: Mob framed my DAD for MURDER. Doe found the
 evidence that CLEARED him after turning up two
 Hart Island corpses killed by the same GUN. So I
 OWE him.

PANEL THREE: SHE CUDDLES UP CLOSER TO HIM.

5 HALPERT: Quid pro QUO: I help him skirt Hart Island
 SECURITY so he can do his THING.

6 WOMAN: How well do you KNOW him?

7 HALPERT: I knew YOU better by the time we'd left the BAR.

PANEL FOUR: NEW ANGLE FAVORING THE TV. ON IT, A SHREWISH FEMALE NEWS COMMENTATOR--OUR NANCY GRACE ANALOG.

8 TV/electric/
 small: --and Channel Nine's FARRAH STONE asks, "Is the
 criminal justice system beyond repair?"

9 WOMAN: Aren't you curious? What is he, ex-cop? P.I.?
 What's with the whole "anonymous" schtick?

((more))

<u>**PAGE SIX, continued**</u>

<u>PANEL FIVE</u>: ON THE COUPLE AGAIN, THE TV INCIDENTAL IN THE
BACKGROUND.

10 TV/elec/small: Farrah Stone: they ARREST, she DECIDES.

11 HALPERT: Dunno, don't care. What do you want me to say?
 I'm in favor of the overall WHAT. NONE of us know
 the WHO or the WHY.

12 WOMAN: "Us"?

13 HALPERT: He's dropped hints from time to time about having
 other operatives, which only makes sense given
 the size of the JOB.

PAGE SEVEN

PANEL ONE: CUT TO AN OFFICE DOOR MARKED "JAMES PAXTIN, CORONER."

1 CAPTION: "I take it he's got inside agents all over the
 CITY."

2 FROM IN/elec/small: --act mighty NERVOUS for an INNOCENT
 MAN, Mr. Trendle. Maybe the D.A. buys
 your story, but my viewers know the
 TRUTH.

PANEL TWO: INTERIOR, CORONER PAXTIN'S OFFICE. HE'S WATCHING THAT
SAME FARRAH STONE COMMENTARY ON HIS OWN PORTABLE TV.

3 FROM TV/elec/small: Why not just come CLEAN, sir?

4 PAXTIN: Because he's not GUILTY, you sanctimonious
 HARRIDAN!

5 PAXTIN: She makes me ILL. How does being a former CRIME
 VICTIM give you the right to play judge AND jury
 on the public airwaves?

PANEL THREE: HE REACHES OVER, TURNS OFF THE TV.

6 SFX: chk

7 PAXTIN: This is NEW YORK. Find me someone who's NOT a
 crime victim! I'd call Farrah Stone an ASSHOLE,
 but that's an insult to assholes EVERYWHERE.

8 PAXTIN: Wait. We're not in the same FRATERNITY, are we?

((more))

PAGE SEVEN, continued

PANEL FOUR: ANGLE TO SEE THAT JOHN DOE'S IN THE ROOM WITH HIM, SEATED, GOING THROUGH A FILE FOLDER AND ITS PAPERS AND PHOTOS. IMPORTANT: DOE'S HOLDING A WATER BOTTLE WITH HIS UNGLOVED HAND.

9 DOE: She's not an AGENT, James. I have STANDARDS.

10 DOE: Marker 36906. Interred last month. Your file says simply "Caucasian woman, blonde, approximately 20-25, no database matches."

11 DOE: "Injuries consistent with fall from nearby building. No sign of struggle. Ruled suicide."

PANEL FIVE: DOE SHOWS PAXTIN A PHOTOGRAPH. WE DON'T HAVE TO SEE IT YET.

12 DOE: This is a photo of her personal effects?

13 PAXTIN: Such as they WERE, boss. No wallet, no I.D.

14 DOE: What did you make of the WALKMAN?

PAGE EIGHT

PANEL ONE: AN EVIDENCE PHOTO OF THE TAPE PLAYER AND A CASSETTE TAPE, BOTH BADLY SHATTERED. I'LL GET YOU REFERENCE ON THE PLAYER, BUT IT'S ONE OF THOSE PRICEY LATE-MODEL ONES THAT WAS BARELY BIGGER THAN THE CASSETTE ITSELF.

1 PAXTIN/off: We call them IPODS now, Grampa.

2 DOE/off: Not this one. Once upon a time, it was the state-of-the-art PORTABLE CASSETTE PLAYER. Very tiny, very EXPENSIVE.

PANEL TWO: DOE QUAFFS THE LAST OF THE WATER IN THE BOTTLE.

3 DOE: Anything on the TAPE?

4 PAXTIN: Unplayable.

PANEL THREE: AS BOTH HE AND PAXTIN GET UP, JOHN (SEEMINGLY ABSENTLY) PUTS THE EMPTY WATER BOTTLE ON PAXTIN'S DESK.

5 DOE: I have a guy. Get it to me, he'll wring something out of it.

6 PAXTIN: I'll sign it out tomorrow, boss. Anything else?

7 DOE: Not tonight. As you were.

PANEL FOUR: PAXTIN WATCHES DOE LEAVE HIS OFFICE--

PANEL FIVE: --AND PAXTIN'S SIGHTS SET ON THE EMPTY BOTTLE.

PANEL SIX: GINGERLY, PINCHING IT BETWEEN THUMB AND FOREFINGER, PAXTIN PICKS IT UP BY THE LIP.

PAGE NINE

PANEL ONE: WITH HIS FREE HAND, PAXTIN PULLS OPEN A DESK DRAWER, REVEALING A SMALL BOX LABELED "FINGERPRINT KIT." NOTE: THERE'S A CELLPHONE ON HIS DESK, BUT WE DON'T NEED TO SEE IT TOO PROMINENTLY HERE.

PANEL TWO: PAXTIN CAREFULLY DUSTS THE BOTTLE FOR PRINTS--

PANEL THREE: --AND, FROM HIS POV, WE GO IN VERY CLOSE ON THE PRINTS, CLOSE ENOUGH TO SEE THAT THERE ARE FINGERTIP MARKS--BUT THEY'RE EMPTY, WITH NONE OF THE WHORLS AND CURVES THAT MAKE UP A PROPER FINGERPRINT.

PANEL FOUR: AS HE SCOWLS AT THE BOTTLE, THE CELLPHONE ON HIS DESK RINGS.

1 SFX: brEEET brEEET

PANEL FIVE: HIS POV ON THE PHONE'S CALLER ID SCREEN.

2 SCREEN: Caller ID:
 PROFOUNDLY UNKNOWN CALLER

PANEL SIX: AS HE SPEAKS INTO THE PHONE, HE TOSSES THE BOTTLE INTO THE TRASH.

3 PHONE/elec: Nice TRY.

4 PAXTIN: What are you, an ALIEN? How do you not leave
 PRINTS?

5 PHONE/elec: Trade secret, Miss Marple. Just get me the TAPE.

PAGE TEN

[Paul--no balloons on this page, just columns of IM text. We can place it all in one column or break it up by panels, your call-- whatever best suits your design sense.]

PANEL ONE: LATER. ANOTHER OPERATIVE--AN IMPOSSIBLY, IMPOSSIBLY HUGE AND SLOVENLY GUY WEARING HEADPHONES SITS TYPING AT HIS COMPUTER. HIS NAME IS STEINWAY. HE IS SURROUNDED BY STATE-OF-THE-ART COMPUTER AND AUDIO EQUIPMENT.

1 COMPUTER TEXT: Encryption ENABLED

2 IM TEXT: Steinway: "Because You Loved Me," Celine Dion. "Exhale," Whitney Houston. "How Do U Want It," 2 Pac. I could go on, but I'll have nightmares.

PANEL TWO: STEINWAY, ANGRY, YELLS UP AT A VOICE FROM ABOVE.

3 IM TEXT: Steinway: Anyway, good call, Mr. D. Every song on that tape is

4 FROM UP: Harold, it's time for my sponge bath!

5 STEINWAY: I SAID I'LL BE UP IN A MINUTE, MOTHER! Gaaah!

6 IM TEXT: song on that tape is from 1996, not one of 'em later than summer. That any help 4U?

PANEL THREE: CUT TO DOE TEXTING ON A BLACKBERRY. HE'S LEANING ON A PARKED MOTORCYCLE IN AN UPPER EAST SIDE ALLEYWAY.

7 IM TEXT: Doe: It confirms a lead, Steinway. Thanks. How's your mom?

PANEL FOUR: ON STEINWAY, FUMING.

8 FROM UP: Harold, Mommy's getting COLD...!

9 STEINWAY: =bhHUHUHUH=

10 STEINWAY/burst: COMING!

11 IM TEXT: Steinway: Don't ask.

PAGE ELEVEN

PANEL ONE: TIGHT ON JOHN'S HAND. HE'S HOLDING HIS CELLPHONE, IS HIGHLIGHTING THE NAME "DET. NISSA ROBBINS" ON THE DISPLAY, WHICH ALSO SAYS "DIALING..."

PANEL TWO: CUT TO THE CUTE FEMALE POLICE DETECTIVE WHO, AS WE DISCUSSED, CAN SERVE AS A POTENTIAL LOVE INTEREST FOR JOHN. SHE'S IN HER PARKED CAR, ON STAKEOUT, AND IT'S FILLED TO ABSURDITY WITH FOOD-TRASH AND USED TAKEOUT COFFEE-CUPS--CLEARLY, SHE'S BEEN HERE A WHILE.
 SHE'S HOLDING A CELLPHONE BETWEEN EAR AND SHOULDER WHILE SHE TAPS AWAY ON HER WIRELESS LAPTOP.

1 DETECTIVE: 'sup, J.D.

2 DETECTIVE: Oh, I got your info right here on the laptop. Not a hardship to DIG. Takes my mind off how bad I have to PISS.

3 DETECTIVE: Yes, another endless STAKEOUT.
4 DETECTIVE: Yes, I know I WANTED to be a cop.
5 DETECTIVE: YES, I like coffee, and STOP making me think about LIQUID, and you owe me a RUTH'S CHRIS for this. ANYway.

PANEL THREE: ANGLE ON HER LAPTOP DISPLAY AS SHE BRUSHES AWAY STRAY POTATO CHIPS AND A SANDWICH WRAPPER. WE'LL GREEK IN SOME SCREEN TEXT.

6 DETECTIVE: You were DEAD ON. Very high-profile KIDNAPPING in the headlines ten years ago. Photogenic little cutie named DANIELLE, who would match your victim's age and general description.

7 DETECTIVE: Rich, doting PARENTS--estranged, yes, good guess--but that's where it goes OFF-SCRIPT:

8 DETECTIVE: There was never a RANSOM DEMAND.

((more))

<u>**PAGE ELEVEN**</u>, continued

<u>PANEL FOUR</u>: SAME, DIFFERENT ANGLE.

9 DETECTIVE: Mom goes BAT-NUTS, accuses Dad of running
 off with their daughter. He claims it wasn't
 HIM--

10 DETECTIVE: --but the court of PUBLIC OPINION rules it
 an OPEN-AND-SHUT CASE. By the time the cops
 move to ARREST, he's RUINED, so he SHOOTS
 himself. No note, and the girl is never
 FOUND.

11 DETECTIVE: Address at the time of the ABDUCTION? Yeah,
 got it right here:

<u>PANEL FIVE</u>: BACK TO JOHN, ON HIS PHONE, STANDING IN THE DOORWAY
OF AN AGING UPPER WEST SIDE APARTMENT BUILDING. THE TARNISHED
SIGN ON THE BUILDINGFRONT SAYS "HENDERSON ARMS, 414 HENDERSON
COURT."

12 FROM PHONE/electric: 414 Henderson Court.

PAGES TWELVE through THIRTEEN

PANEL ONE: JOHN'S POV ON THE HAS-SEEN-BETTER-DAYS APARTMENT
DIRECTORY. PUT SOME PALS' NAMES ON IT IF YOU LIKE, BUT FOCUS ON
"R. SORENTO, SUPERINTENDENT, APT 108." JOHN THUMBS THE BUTTON
NEXT TO THE NAME.

1 SFX: bzzt

2 SFX: bzzt bzzt bzzt

PANEL TWO: TIGHT ON AN APARTMENT DOOR LOCK AS JOHN PICKS IT WITH
LOCKPICK TOOLS. ON THE DOORBELL SET INTO THE JAMB NEXT TO THE
DOORLOCK, WE CAN SEE "108."

PANEL THREE: INSIDE THE DARK APARTMENT, JOHN EXPLORES USING A
FLASHLIGHT. IT'S VERY BACHELORY, BUT NOT TOO WEIRD. SO FAR.

PANELS FOUR, FIVE, SIX (OR SO): JOHN OPENS CLOSET DOORS, LOOKS
BEHIND BOOKCASES. AGAIN, THE ONLY LIGHT IS HIS FLASHLIGHT.

PANEL SEVEN: FANNING AT HIS NOSE AND WINCING THE WINCE OF
SOMEONE WHO'S JUST CAUGHT A WHIFF OF SOMETHING NASTY SMELLING,
JOHN LAYS A HAND ASIDE A BIG BOOKCASE--

PANEL EIGHT: --AND PUSHES IT ASIDE, REVEALING A DARK SPACE
BEYOND.

PAGE FOURTEEN

PANEL ONE, HUGE: JOHN SEES INSIDE THE SMALL ROOM BEYOND--THE HIDDEN DEN WHERE DANIELLE WAS KEPT CAPTIVE FOR TEN YEARS. THE WALLS AND ROOF ARE COVERED IN SOUNDPROOFING MATERIAL, AND THERE'S NOT MUCH HERE EXCEPT A FILTHY COT, A TINY PORTABLE TV (NOT ON) AND AN OVERRUN CHEMICAL TOILET. MAYBE SOME MAGAZINES, SOME DIRTY DISHES, NO CLOTHES.

PANEL TWO: TIGHTER ON JOHN, WHO IS TAKING ALL THIS IN AND APPARENTLY DOESN'T NOTICE THE BURLY BUILDING SUPERINTENDENT-- SORENTO, A PSYCHOPATH IN HIS FORTIES--STANDING BEHIND HIM, ABOUT TO BASH JOHN'S HEAD IN WITH A MASSIVE, MASSIVE PIPE WRENCH.

PAGES FIFTEEN through SIXTEEN

PANEL ONE: AS SORENTO TAKES A BIG SWING, JOHN CROUCHES--

1 JOHN: You don't know how to USE that thing, Sorento.

PANEL TWO: --ELBOWS HIS ASSAILANT IN THE GROIN--

2 SORENTO/burst: =HGGGKK!=

PANEL THREE: --AND CLOCKS HIM WITH THE FLASHLIGHT, SHATTERING IT.

3 JOHN: If you DID, you'd have installed a real TOILET
 for the poor girl at some point.

PANEL FOUR: NOW, SANS FLASHLIGHT, IT'S VERY DARK. SORENTO SCRAMBLES TOWARDS A DRAWER--

PANEL FIVE: --PULLS OUT A GUN--

PANEL SIX: --AND, SCARED, FIRES BLINDLY INTO THE DARKNESS.

4 JOHN/tailless: Careful, Sorento. It's not SOUNDPROOFED out
 HERE.

PANELS: SORENTO, PANICKING, FIRES AGAIN AND AGAIN, BACKING TOWARD A WALL--

PANEL: --UNAWARE THAT--AS WE CAN SEE IN THE MOMENT OF MUZZLE FLASH--JOHN STANDS RIGHT BEHIND HIM AS HE FIRES HIS LAST SHOT.

PANEL: JOHN SLAMS SORENTO HARD INTO A WALL.

PANEL: TIGHT ENOUGH ON JOHN'S MIRRORED GLASSES TO BE ABLE, EVEN IN THE RELATIVE DARKNESS, TO MAKE OUT SORENTO'S TERRIFIED FACE REFLECTED IN THEM.

5 JOHN: Here's how I figure it went DOWN:

PAGE SEVENTEEN--ALL FLASHBACKS

PANEL ONE: SORENTO, TEN YEARS AGO. INTERIOR, ANOTHER APARTMENT. SORENTO'S FIXING A RADIATOR, BUT REALLY, HE'S GLANCING AT THE COUPLE WHO LIVES THERE. THEY'RE SCREAMING AT ONE ANOTHER, OBLIVIOUS TO HIS PRESENCE, AND WE CAN TELL FROM THEIR BODY LANGUAGE THAT THEY'RE REALLY FIGHTING. CROP OR SHADE THE SHOT SO THAT WE CAN'T SEE THEIR FACES.

1 CAPTION: "Building Superintendent knows all about bickering COUPLE and wife's hate for HUSBAND.

PANEL TWO: SORENTO CASTS A SKEEVY GLANCE AT THEIR YOUNG DAUGHTER, WHO SITS NEARBY, HEADPHONES ON, LISTENING TO HER WALKMAN.

2 CAPTION: "Building Superintendent becomes disturbingly attached to their DAUGHTER.

PANEL THREE: LATER. TIGHT ON THEIR APARTMENT DOOR AS SORENTO SLIPS A PASSKEY INTO THE LOCK.

3 CAPTION: "Building Superintendent has a key to their PLACE.

PANEL FOUR: SORENTO, HIS HAND CLAMPED OVER THE TERRIFIED GIRL'S MOUTH TO KEEP HER FROM SCREAMING, DRAGS/CARRIES HER OFF. SHE'S GOT THE WALKMAN STILL, HAS THE HEADPHONES AROUND HER NECK.

((more))

POTTER'S FIELD #1/Script/Ms. Page 20

MARK WAID

PAGE SEVENTEEN, continued

PANEL FIVE: INTERIOR, THE SOUNDPROOFED ROOM. THE GIRL, HYSTERICAL AND FEARFUL, POUNDS FRUITLESSLY ON THE WALL. SORRY FOR THE NUMBER OF CAPTIONS IN THIS PANEL.

4 CAPTION: "He's made 'modifications' to his OWN apartment-- because, just to keep my own stomach from turning, let's assume this is his FIRST pedophilic kidnapping--

5 CAPTION: "--and keeps the daughter hidden away while the WIFE inadvertently plays into his HANDS.

6 CAPTION: "She accuses HUSBAND of the crime so LOUDLY that even when the cops DO question the super, they can barely HEAR themselves over her histrionic ACCUSATIONS--

7 CAPTION: "--and, thanks to a HIDDEN ROOM, they never hear the GIRL at ALL."

PANEL THREE | 49

<u>PAGE EIGHTEEN--ALL FLASHBACKS</u>

<u>PANEL ONE</u>: YEARS LATER. THE GIRL, IN A WORN T-SHIRT, SITS ON THE FLOOR OF HER CELL, CLUTCHING HER KNEES TO HER CHEST, WEEPING, AS SORENTO PUTS HIS PANTS BACK ON. SHE'S LISTENING TO THE WALKMAN.

1 CAPTION: "For the next TEN YEARS, Superintendent keeps the girl under lock and KEY, never seeing the SUNLIGHT, never feeling FRESH AIR...

<u>PANEL TWO</u>: TIGHT ON THE WALKMAN BUTTONS AS HER FINGER HITS THE WORN "REW" BUTTON.

2 CAPTION: "...her only connection to the innocence of CHILDHOOD, the music she replays a million times OVER.

<u>PANEL THREE</u>: MORE RECENTLY--JUST WEEKS AGO. THE GIRL, STILL WITH THE WALKMAN HEADPHONES ON, NOTICES THAT THE HIDDEN DOOR ISN'T QUITE COMPLETELY CLOSED--

3 CAPTION: "A decade is a long time to keep the guard up, though. Eventually, he gets tired or sloppy...

<u>PANEL FOUR</u>: PANICKED, WARY, SHE RUNS THROUGH THE APARTMENT TOWARDS THE FRONT DOOR, TOWARDS HER EXIT, TOWARDS SAFETY--

4 CAPTION: "...she BOLTS..."

PAGE NINETEEN--ALL FLASHBACKS

PANEL ONE: THE OUTER HALLWAY. SHE'S CAUGHT DEAD IN MID-EXIT BY THE SUPER, WHO'S COMING UP THE STAIRS WITH GROCERIES IN HIS ARMS. THEY BOTH LOOK EQUALLY SHOCKED TO SEE THE OTHER THERE.

PANEL TWO: BECAUSE HE'S BLOCKING THE STAIRS DOWN, SHE RUNS UP, AND HE TAKES OFF MADLY AFTER HER.

1 CAPTION: "...runs as far as she CAN..."

PANEL THREE: NOW THEY'RE ON THE ROOF. IT'S NIGHT. REMEMBER, SHE'S STILL GOT HER WALKMAN, HEADPHONES ON, NOTHING ELSE OTHER THAN HER VERY WORN T-SHIRT AND JEANS. SHE'S BACKING TOWARDS THE EDGE OF THE ROOF, HE'S APPROACHING HER, HOLDING OUT HIS HAND, BEGGING HER TO COME BACK.

PANEL FOUR: TIGHT ON HER FEET AS SHE UNKNOWINGLY BACKS UP OVER THE ROOF'S EDGE--

PANEL FIVE: --AND, SCREAMING, SHE FALLS BACK AND OFF THE ROOF. END OF FLASHBACKS.

2 CAPTION: "...and then goes one step too FAR."

<u>**PAGE TWENTY**</u>

<u>PANEL ONE</u>: ON JOHN AGAIN, BUT THIS TIME, WE CAN TELL BY THE BACKGROUND BEHIND HIM, AND MAYBE BY A SLIGHTLY DIFFERENT JACKET (YOUR CALL), THAT HE'S SITTING IN A WELL-LIT ROOM.

1 JOHN: Imagine the sick HORRORS that little girl went
 through for TEN YEARS.

2 JOHN: Imagine how she would have been found a long time
 AGO and SPARED all that if her father had lived
 to prove his innocence.

3 JOHN: If he hadn't been driven to SUICIDE by an angry,
 misguided WIFE who took his death as an admission
 of GUILT...

<u>PANEL TWO</u>: OVER JOHN'S SHOULDER, WE SEE WHO HE'S TALKING TO. IT'S NEWSWOMAN FARRAH STONE. LIKE HIM, SHE'S SEATED IN FRONT OF A TV-STUDIO MAKEUP TABLE, STARING AT HIM IN HORROR, TEARS ROLLING DOWN HER FACE. SHE'S WEARING A SMALL MAKE-UP BIB; WE CAN TELL SHE'S IN THE MIDDLE OF BEING MADE UP FOR THE CAMERA, BUT THE MAKE-UP STYLIST HAS OBVIOUSLY BEEN DISMISSED.
 BEHIND HER, ON THE WALL, WE CAN SEE MOST OF A BIG POSTER ADVERTISING HER SHOW--A HEAD SHOT OF HER AND THE COPY "FARRAH STONE: FOR THE VICTIMS" AND "CHANNEL 9".

4 JOHN: ...and built a TELEVISION CAREER out of her
 VICTIMHOOD.

<u>PANEL THREE</u>: NEW ANGLE ON HER. SHE'S NEARLY SPEECHLESS.

5 FARRAH/whisper: You're LYING.

((more))

PAGE TWENTY-ONE, continued

PANEL FOUR: NEW ANGLE ON JOHN, COLD, HOLDING UP A MANILA
ENVELOPE.

6 JOHN: Here's what you're going to have to UNDERSTAND,
 Ms. Stone.

7 JOHN: I'm only ever interested in the TRUTH.

8 JOHN: And part of that truth TONIGHT is that if
 Sorento's CONFESSION gets LEAKED to any reporter
 in TOWN...

9 JOHN: ...you'll go from PUNDIT to PUNCHLINE so fast,
 you'll be lucky to find a CENTURY 21 jacket that
 fits.

PAGE TWENTY-ONE

PANEL ONE: JOHN HANDS SOMETHING TO FARRAH--NOT THE ENVELOPE, SOMETHING SMALLER.

1 FARRAH: "If."

2 JOHN: It doesn't HAVE to leak.

PANEL TWO: WE SEE WHAT IT IS IN FARRAH'S HAND--IT'S A CELLPHONE IDENTICAL TO THE ONE THE CORONER HAD EARLIER.

3 JOHN/off: I'm VERY loyal to the people who WORK for me.

PANEL THREE: HOLDING THE PHONE, SHE WATCHES JOHN EXIT.

4 JOHN: I'll be in touch.

5 FARRAH: You're BLACKMAILING me.

6 JOHN: Blackmailers TAKE, Ms. Stone. I'm GIVING you a
 chance to ATONE for a horrible act of
 MISJUDGMENT.

PANEL FOUR: LATER. TIGHT ON DANIELLE STONE'S GRAVEMARKER AS JOHN FINISHES CARVING HER NAME INTO IT.

7 CAPTION: "We should all be so lucky."

PAGE TWENTY-TWO

PANEL ONE: JOHN STANDS UP, DUSTS HIMSELF OFF...

PANEL TWO: ...AND TURNS AT THE SOUND OF A VOICE FROM OFF.

1 FROM OFF: John Doe?

2 FROM OFF: That's what they call you, right?

PANELS THREE and FOUR: PAUL, ANGLE THIS NEXT BEAT HOWEVER YOU LIKE--PAST JOHN TOWARDS A WOMAN STEPPING FROM THE SHADOWS, OR ON JOHN DOE REACTING AS SEEN OVER HER SHOULDER, WHATEVER YOU THINK WORKS BEST--BUT ENDING ON A FULLY RECOGNIZABLE SHOT OF THE WOMAN WE SAW IN BED WITH THE PRISON SECURITY AGENT BACK ON PAGE SIX. SHE HAS A PLEADING LOOK ON HER FACE.

3 WOMAN: I'm sorry. I didn't mean to startle you. I
 just...

4 WOMAN: ...I didn't know who else to TURN to.

5 WOMAN: You're my only hope.

6 WOMAN: Please help me.

7 BOTTOM CAPTION: To be continued

Lowell Cunningham's comic book career is not very big... at least if you measure it in terms of the number of issues he's written.

His impact on the larger world has been vast. His comic books about the adventures of the Men in Black have served as the basis for four feature films to date which have done almost $2 billion at the box office. Then there is the animated series, the video games, the theme park ride, and more.

Jack Ooze was a script that Lowell wrote after Hollywood had come calling. The goal was not to have a high-selling comic book. It was simply a one-shot comic to showcase for another concept of his, something that could be looked at by potential licensors.

– Nat Gertler

Jack Ooze

"Origin"

By

Lowell Cunningham

Page One:

A single panel establishing image. It's night. A stylized city follows the slope of a hill, diagonally from top left to lower right. Atop the hill is a square neon sign with large block letters "JFC," and at the bottom of the sign, in smaller letters, "Just Fine Coffee." (This is a tribute to the "JFG" sign which is famous in Knoxville, TN, where I live. Several web pages will show up in Google if you search for JFG Sign Knoxville.)

In the foreground is a dingy warehouse district; there's the occasional overfilled dumpster and papers blowing in the wind. Two well-dressed goons are holding the limp body of Andrew "Jack" Ossman, also in a suit, plus wire-rim glasses. The diagonal of the hillside should lead the reader's eye to the three men at the bottom right of the panel, and the men are facing toward the left of the panel. The farthest goon knocks on a door.

Caption: Recently, in Stone City...

SFX: Nok! Nok! Nok!

Goon 1: Hey, Doc! Open up! We got a nudder one for you!

Title: Origin

Page Two:

Panel One:

Through a peephole in the door we see the eye of Dr. Proctor, something of a stereotypical mad scientist. He's wearing thick glasses.

Proctor: What? You two again? And so soon!?

Panel Two:

Switching to a view inside the warehouse, we see Proctor walking away from the door and toward us. He's balding, with wisps of white hair at the temples. In addition to his thick glasses, he's wearing a lab jacket -- harried, but otherwise a typical scientist. The room is filled with various strange gadgets and gizmos, with lots of dials, displays, and lights. In the background, the two goons drag Ossman inside.

Goon 1: Y'know, you shouldn't oughta leave us standin' around like that.

Goon 2: Yeah. "The Boss" wouldn't like anythin' embarassin' to happen.

Proctor: Tut, tut! Come along.

Panel Three:

Proctor walks toward a large metal vat which is filled with a strange, bubbling liquid. Beside the vat are steps leading a control panel. The goons continue behind him, still dragging Ossman.

Goon 1: Who th' heck says "Tut, Tut!" anymore?

Goon 2: Who th' heck says "Who th' heck" anymore?

Panel Four:

Proctor walks up the steps, toward the control panel. The vat continues to bubble.

Proctor: You... eh... gentlemen are merely performing various unsavory chores for our mutual benefactor while I am wooing the unforgiving mistress that is science.

Goon 2 (whispering to Goon 1): He don't look like a guy what would have a mistress...

Page Two, continued:

Panel Five:

Proctor is now standing at the control panel, looking down at the goons, who are still holding Ossman.

Proctor: The two of you are no better than my so-called peers. Do you know what they said when I tried to describe the sheer revolutionary genius of my destructive reassembly technique?

Goon 1: That you was insane?

Goon 2: In th' membrane?

Panel Six:

Proctor looks a little peevish. Maybe a double-take to anger.

Proctor: No, merely a bit unethical.

Proctor: But I never forgave them!

Page Three:

Panel One:

As the goons look up at Proctor, Ossman suddenly stirs.

Goon 1: Can the balloon juice, Doc. We got a body to get rid of.

Ossman: Uhhhh...

Goon 2: Yeah, time to earn your keep.

Panel Two:

Proctor is excitedly moving toward Ossman.

Proctor: Just a moment! This one is still alive!?

Goon 1: Yeah. For now.

Panel Three:

Proctor is lifting Ossman's head, looking curiously at Ossman's face.

Proctor: Isn't this Andrew "Jack" Ossman, the assistant district attorney?

Ossman: Ooohhhh....

Goon 2: Y'know, I thought he looked familiar.

Panel Four:

Goon 1 nonchalantly waves a gun at Proctor.

Goon 1: I assume there ain't gonna be a problem?

Proctor: No... of course not.

Panel Five:

Proctor returns to the control panel. The goons and Ossman are at the base of the stairs.

Page Three, continued:

Panel Five, continued:

Proctor: Just let me make a few final adjustments.

Goon 1: This whole set-up don't make sense to me. You sure the cops won't be able to identify anythin'?

Panel Six:

The goons have hauled Ossman up the steps. Proctor stands with his back to them, looking grim.

Proctor: I assure you, in just a few moments Mr. Ossman will be indistinguishable from the very primordial components through which life itself arose.

Goon 1: Just so's "The Boss" is gettin' what he pays for.

Page Four:

Panel One:

Proctor gestures to the goons, who are dropping Ossman into the vat.

Proctor: Very well, gentlemen. Do what you must.

SFX: Splash!

Panel Two:

Proctor touches a button on the control panel. The goons move fearfully away from the vat.

Proctor: Now, stand back!

SFX: Click!

Panel Three:

A larger panel here. Energy flows through the vat of liquid, causing Ossman to writhe in pain. Ossman's dialogue should appear as if he is screaming loudly and then suddenly cut off.

Ossman: Yeeeeaaarrhhhh---

Panel Four:

What was once Ossman falls like a drop of water into the vat liquid.

SFX: Bloop!

Panel Five:

Angle on Proctor, very grim, with the goons standing nervously behind him.

Proctor: There you are. Now return to your "Boss."

Page Five:

Panel One:

Goon 1 has an envelope, obviously Proctor's cash payment.

Goon 1: Yeah, that's fine, Doc. Got your money right here.

Proctor: Put it on the table as you leave, if you please.

Panel Two:

The goons are leaving. Goon 1 places the envelope on a nearby table.

Goon 1: Sure thing, Doc. See ya next time.

Goon 2: Let's get outta here.

Panel Three:

Proctor waits solemnly as the door closes behind the goons.

SFX: Slam!

Panel Four:

Proctor is completely changed. He's excitedly operating controls.

Proctor: Finally! A live subject! Let's just hope the reconstruction data wasn't corrupted!

Panel Five:

In a small insert to Panel Six, Proctor reactivates the switch which disintegrated Ossman

SFX: Click!

Page Five, continued:

Panel Six:

In another larger panel, we see Ossman undergoing reconstruction. He's rising out of the vat liquid. The overall effect is that the disintegration process from the previous page is now happening in reverse. Maybe a few more sparks this time.

Ossman: --aaarrrrrgggghhhhhhh!!!!!

Page Six:

Panel One:

Ossman abruptly splashes over the side of the vat, like a wave. From this point on, he is constantly dripping and oozing, no matter what else he might be doing.

SFX: Splash!

Panel Two:

Ossman now has the form of Jack Ooze. He's wearing a suit, but his glasses now resemble swim goggles. He's constantly dripping and we don't see his feet -- his legs terminate in a puddle. He looks with surprise at his new appearance, as does Proctor.

Ossman: What th'!? Who are you!? What've you done to me!?

Proctor: Dr. Proctor. I saved your life. And something more, apparently...

Panel Three:

As Proctor touches Ossman, ooze begins seep up Proctor's arm.

Proctor: Let's have a look... WHAT!?

Panel Four:

Reacting more with scientific interest than surprise, Proctor pulls his hands back and a string of ooze snaps off.

SFX: Snap!

Proctor: Remarkable!

Ossman: Hey, I felt that!

Page Six, continued:

Panel Five:

Proctor speaks calmly to Ossman, who is doubtful.

Proctor: My boy, something truly amazing has happened to you. We must closely study and monitor these changes.

Ossman: What do you mean "we?" You're working with "The Boss." I've been trying to put him away for years.

Panel Six:

Proctor waves his hand dismissively. Ossman looks down at himself.

Proctor: Oh, that's just an arrangement of convenience. He provides filthy lucre and nothing else. If you'll allow me to study you, I'm sure I can supply information which will help incarcerate "The Boss."

Ossman: Hmmm... I guess we could try. Probably won't be doing much else looking like this!

Page Seven:

Panel One:

This is one big panel, with Proctor standing at the top left, taking notes. The rest of the panel shows Ossman in various poses which match what Proctor is saying.

Proctor: Incredible! You can turn entirely into liquid!

Ossman is disappearing into a puddle.

Proctor: Quickly duplicate the characteristics of any fluid you contact!

Ossman is next to an oil can, his color and texture transforming to that of the oil.

Proctor: Travel with the speed of a crashing wave!

Ossman's face is visible, but the rest of him appears as a rapidly moving wave.

Here Proctor appears again, in the bottom right of the panel. He's angrily shaking his foot, where Ossman's ooze has taken hold.

Proctor: And even merge with the bodies of other humans. STOP THAT!

Ossman: Sorry, Doc.

Page Eight:

Panel One:

Proctor and Ossman are at Proctor's desk. On the desk is a computer and various stacks of paper. Proctor is gesturing grandly at the desk. Ossman looks on with a greedy gleam; this is a treasure he's been after for some time.

Proctor: Here you go, my boy. True to my word, every record I have concerning "The Boss." With this you can use your newfound abilities to dismantle his criminal operation.

Ossman: That's great...

Panel Two:

Ossman looks hopefully to Proctor, who is doubtful.

Ossman: But is there any chance I can ever return to normal?

Proctor: Very unlikely. Your biodata was damaged during your reconstruction. It can't be salvaged.

Panel Three:

This takes up the rest of the page. Proctor and Ossman are in dramatic poses. A steady trickle flows from Ossman and into a nearby drain.

Proctor: For years you've been combatting a crime wave. Now, you've become a crime-fighting wave. Jack Ossman is dead. You are now JACK OOZE!

Ossman: Jack Ooze!? Eh, I've been called worse.

Caption: End

I have no particular reason for writing my **Age of Bronze** scripts by hand beyond the fact that I started writing them by hand with issue #1 back in the mid-1990s and haven't changed the habit. No one else needs to see **Age of Bronze** scripts, so there's no reason for me to abandon writing by hand. Scripts that another person, such as a penciler or an editor, needs to be able to read, I write on computer.

I write a full script for an issue before I draw that issue. I intend each script as final, but I often make changes—usually small ones—to an issue's script while I'm drawing the pages. One of the main challenges of writing successful comics dialog is to put in everything that needs to be said, remove everything that doesn't need to be said, and end up with as few words as possible. Of course, that applies to all types of writing intended to communicate, not only comics.

When I write a script that I'm going to draw, I write panel descriptions differently than when I write for another cartoonist. My philosophy about writing panel descriptions for another cartoonist is to specify WHAT to draw, but not HOW to draw it (except in rare cases when HOW is vital to communicating the story). When I write panel descriptions for myself, the WHAT is still important (though I'll take shortcuts), but just as important is recording the emotional quality of the scene I'm imagining as I write. By this I mostly mean the emotions of the characters. Specific emotional qualities easily lose specificity in the time between writing a scene and drawing that scene. A written record helps remind me what I want to express through the characters, the dialog, the settings, and whatever other elements make up a particular scene.

For example, on page 5 of the script for **Age of Bronze** issue #34, the description for comics page 5, panel 5, says:

Laodike looking determined, even tho the bottom has just dropped out of her stomach.

I didn't mean the stomach part literally, although a cartoonist might draw the character's stomach literally dropping its bottom. The comics medium traditionally represents such non-literal aspects literally with great success. **Age of Bronze**, however, remains more naturalistic in style. That panel description told me, as penciler, that my drawing of Laodike's facial expression and posture needed to communicate to the reader how the character felt and, if possible, to make the reader feel the same. Whether my drawing succeeded or not remains another question.

In several places of the included script, I dropped panel descriptions—for example, on script pages 14-15B. At that point, the dialog concerned me more than the panel descriptions. To design the comics page, I relied on my grasp of the characters, the thrust of the scene, and the dialog, instead of panel descriptions.

Sometimes, not often, while I'm drawing, a scene I've written will not work for me. When I've identified definitely that it's the scene that isn't working—that it's not simply a day when I'd rather be doing something other than drawing—I'll revise the script to make it work. That luxury usually doesn't exist when I'm drawing a script by another writer. In that case, I need to figure out a way to make the pictures work as well as possible to fit the script I've been given.

I prefer a change of scene to happen between the end of one comics page and the beginning of the next page. Same for a major change in point-of-view. I don't always make that work, but I strive for that ideal.

My script included here for **Age of Bronze** issue #34 is the final draft, though it includes a lot of obvious revision. First I wrote the page marked 1D, which begins the main story strand of the issue. Pages 1A through 1C I added after completing the first draft. Those pages and some pages of the issue's most important scene, Helen and Achilles meeting on Mt. Ida, went through drafts not included here. You might notice that page 7 of the script specifies that comics page 8 is to be a full-page panel. While I was revising the script during the penciling stage and found that I had to compress the script by a page, I threw the full-page panel idea out.

—**Eric Shanower**
October 2021

PAGE ONE-A SAME SIZE PANELS

① (Troilus stands in his chariot. He holds bow. Charioteer, Philenor, holds horses steady. 3RD MAN in chariot holds spears. Trojan army ranged behind.) CHARIOTS RACING AWAY FROM TROJAN WALL.

Caption: Days pass.

Hektor and Andromache. Her pregnancy is starting to show.

② (Priam on throne, talking to councillors. Dark.)
Caption: And so do nights.

~~Priam:~~ Andromache: ~~I~~ I'm starting to show. Priam ~~won't~~ Will send me away?

Hektor: ~~I want our~~ No. I want our ~~hero in Troy~~ child, born ~~to~~ ~~in a city of~~ bounty and honor, ~~not~~ torn by war. This war must end.

③ (Med. close on Troilus and 3RD MAN in chariot.) CHARIOTS THUNDERING FORWARD.
Troilus: Today No one will kill more ~~Trojan~~ Achaeans than ~~I~~ Troilus.

3RD MAN: I don't know, Troilus. The Storm God is strong in me.

④ (Diomedes and Cressida make love in Diomedes's hut by night.)

⑤ (Close up on Troilus shouting, angry and determined.)
Troilus: FORWARD! ~~FASTER!~~

⑥ (Priam on throne, talking to councillors. Late at night. One councillor holds lamp. Idaeus is there + a scribe, too, if there's room.)

The treasury's nearly depleted by all the ~~so many~~ bribes to allies. And ~~still~~ we're losing them. Esseus took ~~all~~ his men back to Thrace tonight.

Priam (A): Esseus, ~~took~~ his men back to Thrace tonight. ~~I can't afford~~ ~~bribes to bribe~~ Bribing allies is becoming ~~These bribes to allies~~ the treasury's nearly depleted with all the bribes ~~home~~. My daughters, too.

Priam (B): I want my wife ~~and daughters back~~ child. The babies are born ~~by now~~.

⑦ (Troilus shoots arrow savagely into an Achaean— deadly strike. Troilus in chariot. The 3RD MAN in chariot is savagely speared by several Achaeans at once.)
3RD MAN: AAG--

⑧ (Evening in Achaean camp just after day's battle ends. Ag takes off helmet as he enters his hut. Odysseus dismounts from his chariot to follow Ag inside.)
Odysseus: Agamemnon, supplies and allies are still reaching Troy.

PAGE ONE-B

① (Inside Ag's hut. Servants remove Ag's armor. Od enters.)
Agamemnon: But We've sacked all the nearest ~~cities~~ towns -- devastated the countryside...

Odysseus: There's only one way to make sure ~~no one can~~ nothing gets in or out of those walls...

② (Close on Odysseus.) (a, a) ...the army must surround the city completely and continuously, day and night...
Odysseus: (b) ...Lay siege.

③ (Ag and Od look toward door of hut, where voice comes from.)
Ag: (a) ~~Siege.~~ (b) ~~Yes,~~ I suppose you're right, Odysseus. ~~No other~~ Nothing else is --
Palamedes (o-p): Son of Atreus, Agamemnon!

④ (Palamedes enters. Ag looks at him. Odysseus is disgusted, turns away.)
Ag: (a) ~~Ah!~~ Palamedes. (b) What is it?
Pal: Somehow the Trojans are still being supplied. We've ~~got~~ must to stop ~~that~~ it.
 I suggest we lay siege ~~to Troy~~ ⟹

⑤ (Ag confronts Pal. Ag's got little patience, but Pal doesn't read him & is earnestly trying to help.)
Ag: (a) Siege? ~~Hmm.~~ (b) That means an idle army. Idle men grow restless.
 They're ~~already~~ grumbling about food. Who knows what they'll grumble now about with nothing to do? About their leader perhaps?

⑥ (Med close on Palamedes, earnest.)
Palamedes: I'll find ways to keep them occupied -- games, contests. ~~And~~ Achilles should be ~~back before long~~ return soon with grain from Mysia. And I'll ~~find ways to occupy the army~~ -- games, contests --

⑦ (Ag turns casually away from Pal, waving hand dismissively. Pal is surprised. Od has evil look.) rally their spirits, cousin. But
Agamemnon: (a) ~~Yes, I'm certain you'd~~ ~~we can't lay siege~~ I just remembered -- the gods have ~~decreed~~ decreed that Troy will fall by spear and sword. We ~~have to~~ can't defy ~~retain~~ the gods' favor. ~~So we can't~~ (b) ~~So no~~ siege. ~~Thanks~~ But thank you anyway, cousin.

AOB #54 by E.J. Shanower 18 DEC 2018

PAGE ONE-B CONT'D.

Ag: But, uh, isn't it true ~~that~~ the gods said that Troy must fall by ~~sword and spear?~~ ~~Yes, and we can't defy the gods.~~

Ag: Uh, didn't the Delphic oracle, ^tell us ~~say~~ that Troy must fall by sword and ~~spear?~~

Pal: I don't ~~remem~~

Ag: ~~Yes~~ ~~and we can't defy the gods!~~
 ~~So no siege.~~ ~~Thank you anyway, cousin.~~

⑤ (Ag is annoyed that now Pal will probably think siege was Pal's idea. He's starting to explain, B and is angry to have to explain, but Od jumps in with ~~telling it ~~idea^ "warning to As and to shame Pal, even tho' he's going against his own advice.)
Ag: ~~Siege~~ Yes, a siege - -
Od: ~~I~~^A siege, means an idle army. Idle men grow restless. They're grumbling about food now. Who knows what they'll grumble about with nothing else to do? About their leader perhaps?

⑥ (Close on Palamedes, earnest.)
Pal: ^But Achilles should return soon with grain from Mysia. And I'll find ways to occupy the army - - games, contests~~, ---~~

⑦ (Od breaks in, determined not to let Pal look good. Pal is confused. Ag finally gets it and plays along with Od.)
Od: ~~But~~ ^Agamemnon, didn't ~~the~~ the Delphic oracle tell us that Troy must fall by spear and sword?

Pal: I don't remem - -

Ag: Yes! And we can't defy the gods! So no ~~siege.~~ Thank you anyway, cousin.

① Hektor: A moment please, father.
~~Priam: Hektor?~~
~~Hektor: I'm concerned about Troilus. Won't you persuade him to stop risking himself foolishly?~~
~~Priam: Hektor, we're at war. I can't hold my sons back from battle while the sons of my people offer their lives.~~

② ~~Hektor/Hektor: I'm concerned about~~ →Troilus is→ He's reckless, with his own life and ~~in battle~~
with the lives of his men. ~~They die~~
~~by dozens.~~

~~Hektor: He's reckless with his own life, too.~~

Ⓟ Priam: ~~You~~ lead the army, Hektor. Command him.

③ Hektor: I'd command him to stay at home if that wouldn't shame him before Troy.
In the thick of battle I have no control over him. ~~He makes himself a target~~
~~for Achaean spears.~~ He makes himself a target for Achaean spears.

Ⓟ Priam: Yes, Troilus has become quite a warrior—almost god-like. I ~~watch~~ him from the walls,
fascinated. While ~~he~~
~~He makes himself a target for Achaean spears~~ his men die by dozens. And

④ Hektor: ~~Only~~ the gods know why ~~he~~ hasn't been killed by now.
 Troilus

⑤ Priam: That's why I spend half each night in the temple praying—to protect my
sons—who are my strength and the shield of my city.
Ⓗ ~~Hektor: Father, won't you persuade him to stop risking himself foolishly?~~
~~Hektor: Father, won't you persuade him to stop risking himself foolishly?~~

⑥ Priam: Hektor, we're at war. I can't hold my grown sons back from battle while the sons of my people
~~Priam: Hektor, we're at war. I can't hold my grown sons back from battle ...not while~~ offer
~~the sons of my people offer their lives.~~ their
 lives.

 I know, but since Cressida---
⑦ Hektor: Father, I---

⑧ Priam: I must go to the temple. I'll pray an extra prayer for Troilus. And for you.
 ~~AND FOR MYSELF~~

Ⓗ Hektor: ~~Father~~ Bub, father---
 Priam: AND FOR MYSELF.
⑧ Hektor: ~~I~~ Yes, father...
 (small letters)

PAGE ONE - D

① (Long shot of Mount Ida, majestic.)

Caption: Mount Ida, south of Troy.

② (Closer. On side of mountain we see a group of women + male servants trekking up the hill. Horses pull several empty chariots behind them. The women include Helen, Aithra, Hekuba, and Laodike. The children are ~~Bunanus~~, Idaeus, Munitus, and Hippothous.)

③ (Medium on Laodike, stumbling. One of the male servants holds out his hand to steady her.)

Laodike: Oh!

Male servant: Careful.

④ (Medium on Laodike)

Laodike: ~~I'm~~ ~~so tired it~~ A daughter of Priam, I shouldn't have to climb ~~the~~ ~~mountains like a~~ ~~peasant~~ goat girl. I'm tired. ~~it's~~ The day's getting too warm for this.

~~do~~

Male servant: We're almost to the top, daughter of Priam. ~~Then it's downhill~~ It'll be easier going downhill ~~and then you so may ride again.~~ At the bottom you can ride again.

⑤ Laodike: A daughter of Priam shouldn't have to climb mountains like a goat ~~girl in the first place.~~

⑥ (Hekuba turns to look at Laodike and ~~she~~ scolds her.)

Hekuba: ~~I~~ If a wife of Priam can climb this mountain without complaint, so ~~should~~ ~~the~~ can Priam's daughter.

Laodike: Yes, mother ~~but it's just not right.~~

PAGE TWO

① (Med close on Aithra, carrying Munitus. Helen nearby ~~carrying the baby~~ ~~Idaeus~~) not carrying the baby

Aithra: Well, I'm not Priam's daughter, so I'll complain all I want.
My ~~These~~ bones are too old for this sort of travel. √Give me a good ship.
Not a ~~weak~~ whisper of breeze. Give me a strong wind and a ~~good~~ fast ship.

② (~~Helen as it looks out to sea over the mountainside~~)

~~Helen:~~

② (Hekuba scolds Aithra. Aithra accepts the gentle rebuke, tho' she doesn't much like it inside.)
Hekuba: Not while Achaean ships ~~are~~ raiding the coast. ~~The~~ Tend to your
Not for us.
 charge, old woman, and be thankful ~~you have~~ yet another royal child ~~to raise in your keeping~~.
 for
Aithra: Yes, ~~great queen~~ daughter of Dymas. to raise.

③ (Aithra whispers to ~~Helen~~ Munitus. ~~Helen overhears & speaks sharply to Aithra~~)
Aithra: ~~Great grandmother~~ ~~I bring you~~ raise you to ~~be the~~ be greater than your
 ~~listen to me, Munitus~~ I'll
 grandfather you.

~~Helen: Aithra!~~

④ (Aithra looks up startled & seemingly confused. ~~Helen is furious~~, but keeps her ~~self~~ Hekuba is grim,
 calm & speaks low & confidentially.)
Hekuba: ~~The~~ ~~By~~ By that ~~grandfather you mean is~~ And which grandfather is that?
~~Helen:~~ ~~Priam, of course.~~ You ~~remember that~~ Munitis
~~is my son, a twin of~~ ~~Idaeus's twin brother.~~ If you ~~want to raise~~ ~~the boy, you'll~~ that
child, you'll remember that he's Helen's son
Aithra: ~~Of course.~~ Priam, of course, daughter of Dymas.

⑤ (Close on Hekuba, speaking grimly to Aithra.) Just that Munitus's
Hekuba: ~~If you want to raise that child, you'll~~ remember ~~that he's Helen's son,~~ his parents are Paris and Helen, and he's
 ~~and~~ twin brother to Idaeus. Forget ~~that~~ for a moment and he'll be ~~beyond~~
out of ~~of~~ your reach. of all people
⑥ Aithra: ~~Yes, great queen. The situation, it's.~~ ^Aithra, mother of Theseus, ~~If anyone understands,~~
⑦ ~~Helen: spe~~ PAGE THREE
① (Fire behind ~~Hele~~, looking out over the water from the mountainside.)
~~I spoke~~ ~~Helen~~: ~~I don't see any~~ No ships on the water now ~~maybe they're gone~~
 Full bottom tier panel.
Helen: ~~Well,~~ ^

That isn't the sort of thing Aithra, mother of Theseus, forgets does not forget.

CONTD ⇃⇃

PAGE THREE (CONT'D)

② (~~Close~~ Medium close on Laodike, ~~hopeful + optimistic.~~ *hardly daring to hope -- reluctant to shed her lethargy, but unable to suppress hope.*) *we'll find* *fighting is*
Laodike(a): Maybe they're gone.
Laodike(b): ~~Maybe they're all gone.~~ Maybe when we get back to Troy, the *home* ~~war~~
~~be~~ *be*
~~will~~ over and they'll ~~all~~ gone.

③ (Close on Helen, surging with a hope she knows can't be fulfilled. *Self-aware that the war's over her.*)
Helen: ~~Oh~~ If only ~~that was true~~, ~~Laodike~~. that could be true.

glances sideways at Helen, blaming silently.
④ (Laodike, hopes dashed, ~~hangs her head~~. Helen, nearby, in pain + conflicted emotions.)
Laodike: ~~But~~ It won't be. ~~I know it.~~ ~~That's not how life works.~~ The gods are never so ~~that~~ kind.

⑤ (Hekuba tries to rally their spirits. Laodike sourly comments.)
Hekuba: They were kind enough to give us a respite in Dardanus while we bore our sons. ~~But~~ But now Priam ~~now~~ calls us back ~~to~~ ~~where we belong~~ beside our husbands ~~in Troy.~~
Laodike: Philobia gave us the respite in Dardanus -- *where she's smart enough to stay.*

PAGE FOUR
① (~~Close on Helen. Laodike quietly comments behind Helen.~~ *(Hekuba tries to be positive. Helen is sorrowful, doubting.)*
~~Helen(a):~~ Hekuba: Now Priam calls *this family* back to where we belong -- beside our husbands in Troy.
Helen (b): ~~We obey.~~ Beside our husbands.
~~Laodike: Philobia gave us the respite in Dardanus -- where she's smart enough to stay.~~

② (Hekuba takes baby Hippothous from a ~~nurse~~ *serving woman.*)
bringing
Hekuba(a): And we return ~~home~~ in triumph ~~to~~ ~~our husbands~~
sons!
(b): Hippothous of Troy, the fifteenth son I've borne to Priam.

CONT'D ⇓

PAGE ~~FOR~~ ~~THREE~~ FOUR CONTD.

③ (Hekuba raises Hippothous high into the air.)

Hekuba: Hippothous of Troy, the ~~fifteenth son~~ fifteenth son I have borne to Priam. Shine favorably upon him, O sun god --

(Hippothous starts crying.)

Hippothous: WAAAH!

~~PAGE FOUR~~
~~THREE~~

④ (Hekuba clasps Hippothous to her breast sympathetically.)

Hekuba: (a) Oh, Hippothous -- ~~mother didn't mean to scare you.~~ mother didn't mean to scare you. ~~It's as if you know where~~ It's as if you know where I were going

(b): Oh, gods! We were ~~away~~ from Troy. ~~We're~~ safe! How can Priam summon us back? ~~How can I~~ protect his children if he won't Let me?

⑤ (Munitus in Aithra's arms & Idaeus in another serving woman's arms also start to cry. ∫ Laodike watches. Helen goes to Idaeus.)

Munitus: OAAH!

Idaeus: Ah -- Ahh -- ~~too~~ Munitus and ~~Idaeus~~

Laodike: ~~Aithra~~: Now he's got ~~the others~~ Munitus and Idaeus crying, too.

⑥ (Hekuba, trying to joggle Hippothous, talks to one of the guards.)

Hekuba: ~~I surrender!~~ I surrender! We'll rest here during the heat of the day. ~~He looks~~ Surely this high on the mountain we're out of danger from raiders. (~~This seems like a good time to~~ rest during the heat of the day.)

Guard: Yes, ~~great queen~~ daughter of Dymas

Hippothous: -- aaaaah --

① (Servants spread blankets on the ground in the shade of some trees. The party is among some pines on the edge of a meadow high on the mountain. The ground is slightly sloping. It commands an excellent view of the vista and water. The peak of the mountain is nearby, not too far above them, but not too close either. ∫ Helen is nursing Idaeus. Hekuba is nursing Hippothous. Aithra stands with Munitus a little apart from the others. Laodike approaches Aithra.)

Laodike: ~~Aithra, Let me nurse him. Aithra~~ Aithra, My breasts ache to nurse him. Please let me.

~~Helen~~ Munitus: ~~...~~ ...waaahhh --

CONTD ∥∥

PAGE ~~FIVE~~ FIVE ~~FOUR~~ CONT'D.

② (Aithra, shocked, draws away.) Laodike. Aithra, my breasts ache to nurse him. Please let me.
Munitus: ...waaaahhhh--
Aithra? ~~Out of the question!~~ Absolutely not!

③ (Laodike pained + pleading.) behind a tree
Laodike: ~~Please~~ Please -- I'll stand ~~by the trees over there~~ -- no one will see ~~you~~ ...
Aithra: ~~Absolutely not!~~ Helen will do it, when she's finished with Idaeus. ...
~~nurse will be found for him. And Munitus will~~ ~~when we reach Troy~~ have a wet nurse ~~then, back at~~ in Troy, so don't
get any ~~more~~ clever ideas.

④ (Aithra puts her face close to Laodike's + hisses.)
 Laodike, you're home.
Aithra: The ~~only~~ one idea you should have, is to lie with your husband as soon as ~~we get~~
~~your can~~. Bear another child! ~~And so~~ Forget this one! 11-14-14

PAGE ~~FIVE~~ ~~FIVE~~ SIX
① (Shot of the sun shining down.)

② (Long shot of women + attendants still sitting ~~in the meadow~~ in the shade of
the trees. Peak of mountain rises nearby. Remains of a meal ~~are~~ are on the blankets--
jugs, cups, breadcrusts, knife in a bowl of cheese which is half empty.)

⑤ (LAODIKE LOOKING DETERMINED, EVEN THO THE BOTTOM HAS JUST DROPPED OUT OF HER STOMACH.)
LAODIKE: Laodike, daughter of Priam, does not forget.

CONT'D.

PAGE ~~FIVE~~ SIX CONTD.

③ (Med dose on Helen, sitting beside the sleeping Idaeus and Munitus, waving a cloth over them to keep the flies off them. Laodike dozes next to the babies.)

④ (Helen looks up at peak. We see her from behind in foreground, peak in distance.)

⑤ (Tight close up on Helen's eyes as she stares at u-p peak.)

⑥ (Helen talks to guard.)

Helen: Isn't there an altar on the mountain top?

Guard: Yes, just this side of the peak of Gargara.

⑦ (Helen looking at peak - similar to panel 2.)

PAGE ~~SIX~~ SEVEN

① (In foreground Hekuba dozes, leaning against a tree trunk in the shade. Hippothous sleeps in her lap. In middleground, Helen has turned her head to look at them.)

② (Helen ~~whispers~~ joggles Laodike's ~~shoulder~~ and whispers to Laodike across the sleeping babies.)

Helen: (whisper): ~~Laodike~~ Altres, keep ~~the flies off the babies for a while.~~ watch over the babies for a while. No arguments.

Laodike: ~~Mm whuh? Yes, I will.~~ Hmuh? Uh, yes, daughter of Leda.

③ (Helen has stood & is walking away from the group, not far from the group yet. She indicates a jug of wine & the guard is bending & reaching for it.)

Helen: Bring that ~~container~~ jug of wine and escort me.

Guard: Yes, daughter of Priam.

<u>PAGE ~~SEVEN~~ ^{SEVEN} ~~SIX~~ CONT'D.</u>

④ (Helen + guard walk up the mountain through a meadow.)

⑤ (Guard points over a rise past clumps of trees + bushes.)

Guards: I believe it's ^{the altar's} just beyond that knoll.

Helen: ~~God~~ ^Stay here ^{Give me the wine and} ^{to} ^and keep watch. ^{The goddess leads me on.} ~~Call if I need you.~~

⑥ Guard: But there may be wild animals or—- ^{Do as I say.} ~~I~~ ^If I need you, I'll call.

⑦ ~~Helen: I said stay here! The goddess calls me.~~

(Helen carries jug up mountain.)

<u>PAGE ~~SEVEN~~ EIGHT</u> (FULL PAGE PANEL) (Helen reaches mountaintop.. just below the field in front of it.)

PAGE ① NINE ① (In a round flat area near the top of the mountain ~~Helen~~ enters between two stands of scrubby pines and sees an altar on the far side of the area, ~~&~~ with the peak of the mountain rising above. The round area is circled with clumps of trees alternating with clear spaces, like a round room with many doors ringing it. One side, however, ~~is~~ has ~~a~~ thick pine woods.)

② (Helen stands before the altar and pours a libation onto the ground in front of it.) She has taken off her veil, so her hair is unbound.)

Helen: ^(a) ~~Goddess of Love, speak to me.~~

Helen ^(b): ~~Tell me what I should do.~~

<u>CONT'D.</u>

⇊

PAGE NINE CONT'D.

(3) Helen: G-Goddess of love" ~~speak to me~~.

(4) Silent, Tell me what ~~I should do~~.

(5) Helen(O): Should I ~~continue on~~ return to Troy, ~~back~~ to a city ~~still at war?~~ where
men bleed every day because of me... where women's watch me with
eyes
~~eyes filled~~ with hatred...

~~[scribbled out]~~ where children are born into strife they didn't choose?

 renounce your gifts and
Helen (6): Or should I ᴧ fly down this mountain back to the arms of the Achaeans?

~~Can I renounce the gifts you gave me? Gifts I never asked for but~~
~~can't resist -- my home in Troy... Priam's beautiful sons~~

 CONT'D. ↓↓↓

PAGE ~~EIGHT~~ ~~SEVEN~~ NINE CONT'D.

③ (Med on Helen, emptying the last of the wine.)

Helen: Should I continue on to Troy, back to a city ~~that war~~ still at war? ~~where~~
men ~~bleed~~ every day because of me... where ~~the~~ women ~~watch~~ watch me with
eyes ~~brimming with hate~~ that can't disguise their filled with hatred... where children
are born into strife they didn't ~~cause or choose.~~

④ (Close up on Helen, sorrowful.)

Helen: Where children are born into strife they didn't ~~cause or~~ choose.

⑤ (She drops the jug.)

Helen: ~~Speak, Goddess. You led me to this.~~ back to
 (a): Or should I fly down this mountain right now — ~~back~~ to the arms of the Achaeans?
 (b): ~~Should I~~ Let ~~them take from me whatever~~ their recompense ~~they require~~ for my
 ~~the actions you required of me~~ — ~~my flight to Troy,~~ my love for Priam's son, the
 long journey to ~~glorious Troy.~~ Can I Renounce ~~forever~~ the gifts you gave me? (Gifts I never asked
 for, but ~~impossible~~ to resist — my ~~home in Troy,~~ Priam's beautiful son.)

⑥ (Helen dips her head & closes her hands in front of her mouth desperately.)

Helen: Paris! Paris! My blood still heats when I think of him ~~in the curve~~
 of his lip... the ~~weight of his arm~~ ~~pulling me to him~~ the ~~curve~~ ~~of his bicep~~ and ~~this~~ ~~touch~~ fingers
 ~~holding me against him~~ — ah! —

PAGE ~~EIGHT~~ TEN

① (Helen looks up profoundly sad.) trustworthiness, even dependable

Helen: But Paris ~~isn't~~ ~~all a man should be~~ not brave like Hektor, not ~~smart like~~
 ~~the generosity that~~ ~~granted to~~ me before...
 ~~Traitors, not even as smart as~~ ~~Menelaus~~ If ~~he~~ only had Priam's
 ~~But I wish Paris had as many good qualities out of bed~~ bravery, or
wisdom ~~good as Priam... or even as generous as Menelaus was~~ even the generosity Menelaus always
 ~~should me before...~~ led

② Helen: ...before ~~all this~~ you ~~led~~ led me to all this, goddess.

③ (Helen is startled by the sound of singing not far off.)

O-P: — husband, the smith-god, came up with a plan ♪
 And forged a bronze net thin as hair. ♫

Helen: ?

O-P (sheep): Baaa-aa-ah! Meh-eh-eh-ehhh!
 Meeeh-eh-eh!

CONT'D ↓

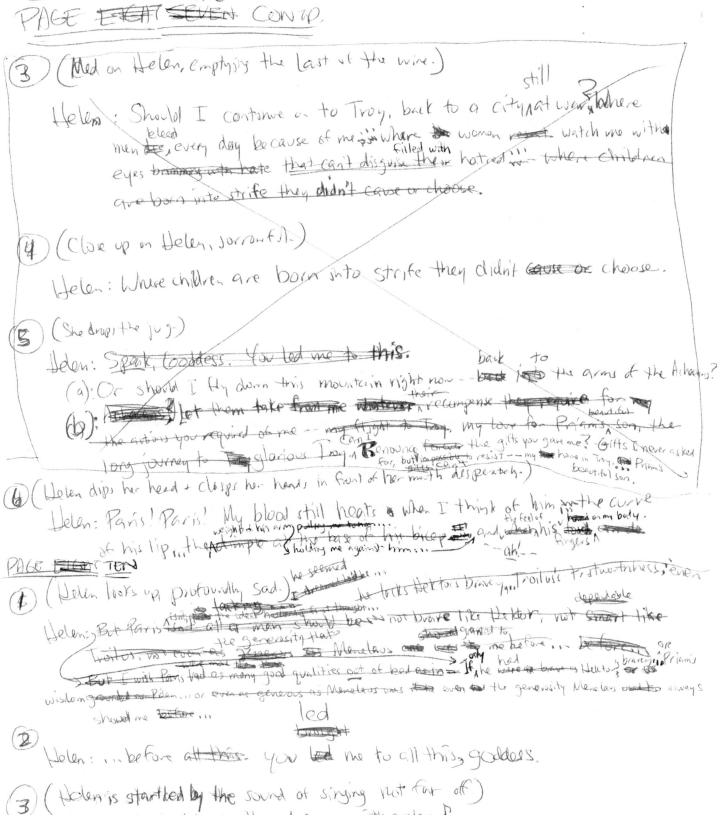

PAGE ~~NINE~~ TEN ~~EIGHT~~ CONT'D

4 (~~Helen looks around desperately.~~)

Achilles (o.p.): ♪ He secretly strung it up over the bed, ♪
Concealing his trap for the pair.

REDISTRIBUTE
SONG AMONG
PANELS

5 (Helen, snatches up her veil and ducks behind the altar of rough rocks.)

Achilles (o.p.): ♪ The goddess of love and the brash god of war
Soon lay down together in love. ♪

6 (From Achilles p.o.v. His hand pushes aside a branch to show the round meadow where the altar is. Helen can't be seen behind the altar.)

Achilles: (a) ♪ And when their love-making had climaxed, the net
Dropped promptly on ~~them~~ from above, ♪♪
(b): They couldn't escape when the smith-god ~~leapt in~~
And summoned the rest of the gods ♪♪

7 (Full body shot of Achilles striding confidently ~~forward~~ across grassy meadow. He carries his spear, but he wears no armor. Over his shoulder is a sack of grain for sacrifice. He also has a small bag of flint & tinder. ♪ He also leads a ~~lamb~~ young sheep on a leash. ♪ He wears a sword, too.)

Achilles: ♪ Who, seeing the lovers so handily caught,
Responded with jests, winks, and nods. ♪♪

Sheep: ~~Baaaa-ahh~~ Meh-eh-eh!

~~PAGE NINE~~
ELEVEN
1 (Kneeling near altar, he kindles a fire in a fire pit some way in front of the altar.) No more singing.

Achilles: Hmm-hm ♪♪

2 (He slits the ~~goat's~~ sheep's throat with his sword.)

3 (He stands in front of the fire. The sheep is roasting ~~on~~ it. Achilles tosses grain onto the fire.) prepare a pyre for signalling

Achilles: (a) God of ~~the~~ Mount Ida, I'm here at ~~the~~ highest peak of ~~Ida~~ to ~~choose a spot for a pyre to signal~~ Achaean victory when the war ends. ~~But~~ (b) Before I left ~~the~~ ~~beach at Troy~~ my mother, child of ocean, instructed me to offer sacrifice ~~here~~ ~~upon the highest~~ first. ~~peak of Ida.~~

THIS DIALOG GOES IN PANEL (4) CONT'D↓

PAGE ~~NINE~~ ELEVEN CONTD.

④ (Med close on Achilles.)

Achilles⑥: So I ~~here with~~ give praise for the successful battle in Mysia. I defeated ~~the~~ evil Teuthras who took advantage of Telephus's troubles. I set Telephus back on his throne.

⑤ (We see Helen in foreground, crouching in fear behind the altar. In the background Achilles still prays.)

Achilles⑨: Now I return to the Achaeans camped before Troy, bringing ships full of Mysian grain to stop the army's hunger pains.

⑥ (Close up on Achilles) (a): I give thanks for these successes...

Achilles: But ~~when will I~~ win glory ~~in battle beneath the walls of Troy?~~ ~~every day away from Troy is a day lost. Too soon my shade will journey down to the land of the dead.~~

~~(b): Before long my shade will journey down to the land of the dead.~~

~~My glory must come soon!~~ Every day away from Troy **is a day lost**

⑦ (From behind Achilles, we see smoke ascending into sky. tending toward worm's eye view.)

Achilles: ~~Gods,~~ You've ~~given us~~ instilled the eternal need for men ~~to fight other men.~~ Every day away from Troy is a day lost. ~~Before long,~~ Too soon my shade will ~~journey down to the land of the dead.~~ When will I win glory in battle ~~beneath~~ at the walls of Troy?

PAGE ~~TEN~~ TWELVE

① (Achilles is distracted by something on the other side of the altar.)

Achilles: Grant that on my return ~~to Troy~~ to Troy I --

② (Achilles crouches, alert, sword in hand, watching warily.)

Achilles: Show yourself!

CONTD.

PAGE ~~ELEVEN~~ TWELVE ~~TEN~~ CONTD.

(#3) (Helen stands ~~slowly~~ up.)

~~(Achilles relaxes a little, lowers sword, surprised.)~~

~~Achilles: Are you the nymph of this peak? Or a nearby river?~~

~~Helen: No, I—~~

(#) (4) (Achilles falls to his knees, drops his sword, and raises his arms in typical praise gesture.)

Achilles: ~~You're a goddess!~~ Yes, ~~with beauty such as yours, I should have known by your~~ ~~beauty:~~ Goddess!

11/15/14

(#) (Helen sits on top of the altar.) Achilles: Or are you the nymph of this peak... Or a nearby river?

(5) ~~Helen: No,~~ ~~I~~ — I claim the ~~sanctuary of the altar!~~

(6) (Achilles relaxes a little, lowers arms halfway, skeptical.)

Achilles: ~~But~~ ~~You have a goddess's beauty. But~~ ~~why would a goddess hide behind the altar?~~ Or ~~Are you instead~~ the nymph of this peak—or a nearby river?

~~Helen: I claim the sanctuary of the altar.~~

(#) (7) ~~(Achilles stands. Helen climbs onto altar to sit.)~~

 instead maybe
Achilles: Are you ^ the nymph of this peak? Or ~~of~~ a nearby river?

Helen: ~~Don't touch me! I claim the sanctuary of the altar.~~

(6) PAGE ~~ELEVEN~~ THIRTEEN

Achilles: ~~Don't worry. I won't hurt you.~~

 an ~~Who are you?~~
Helen: You're ~~one of the~~ Achaean. ~~What's your name?~~
 what's your name?

CONTD.

\\|/

PAGE ~~TWELVE~~ THIRTEEN ~~ELEVEN~~ CONT'D.

① (Achilles stands, proud and forthright. ~~Maybe you've heard it.~~ (b) The gods bestow the eternal need for
~~men to fight other men,~~ with fame the only compensation ~~that will last.~~

Achilles: (a) I'm the son of Peleus of Phthia and ~~of the priestess~~ Thetis,
daughter of Nereus. (b) My name is Achilles. ~~Maybe you've heard it.~~

② (Helen anxious.)

Helen: ~~Son of~~ Peleus? He ~~was companion of~~ sailed with my brothers on the ship Argo!
Do you know them? ~~Kastor and Polydeukes,~~ The twin sons of Tyndareus, Kastor
and Polydeukes?

③ (Achilles loses himself in memory.)

Achilles: (a) Yes! (b) I saw them once in my father's hall when I was very young -- before
~~my father~~ I was sent to be tutored by the ~~Kentaur~~ Cheiron. They ~~looked~~ seemed like gods to
me -- tall and beautiful --

④ (Achilles, frowning, puts two and two together.)

Achilles: ~~But If~~ Wait-- ~~if these two said they are~~ they're your brothers?
Then you ...

⑤ ~~⑤~~ ~~Helen: Yes.~~

⑤ (Helen, realizing ~~her~~ she's given herself away, looks down at the
ground, ashamed, guilty, sorry for opening her mouth.)

⑥ ~~⑤~~ (~~Achilles and H~~ stares at Helen while she stares at the ground.)

Maybe you've heard it:
~~Have you heard of me? I bow before the~~
~~eternal need bestowed by the gods that men~~
~~fight other men.~~ The gods bestow the eternal
need for men to fight other ~~men.~~ This will ~~be my~~
~~life until I die.~~ But ~~I was~~ promised ~~me glory that~~ seems
~~so long in coming.~~

↳ with fame the only compensation ~~that will~~ last.

CONT'D ⟩⟩⟩

Yes. I've watched you fight at Troy. ... too. Peleus sailed on

③ (Helen anxious.) I've heard of your famous parents

Helen: Peleus? He sailed on the ship Argo in company with the sons of Tyndareus -- Kastor and Polydeukes.

④ (Achilles loses himself in memory.)
Achilles: The glorious twins! I saw them once, in my father's hall, long ago, before I was sent to Cheiron, when I was very young. They seemed like gods to me -- tall and beautiful. I wanted to be just like them -- Tell me, please, son of Peleus,
Helen: Are they with the Achaeans at Troy? before Troy?

⑤ Achilles: No -- that was long ago, before I was sent to Cheiron. But their sister, the wife of Mycenae's High King -- the visited the army just before we sailed for Troy.

Helen: Klytemnestra? Is she well?
⑥ Achilles: I'm afraid She was in great sorrow.

Helen: Why?
⑦ Achilles: She'd lost a daughter --
Helen: A daughter? Which one?

PAGE FOURTEEN
① Achilles: Iphigenia. The High King gave Iphigenia daughter as a sacrifice to the goddess -- on an altar like this one. I saw it with these eyes.
Helen: Iphigenia? What do you mean? What are you saying?
Achilles: On an altar like this one. I saw it with these eyes. She gave her life so that the Achaeans could bring back her mother's sister, Helen to protect me -- and so that the Achaeans could recover Helen...
② Helen: Gave her life? Little Iphigenia?
③ Achilles: You're -- Yes -- and so that the Achaeans could recover the other. daughter of Tyndareus
④ Achilles:
Helen: Me?
⑤ Achilles: What? You.
⑥ Achilles: Oh.

PAGE ~~THIRTEEN~~ FIFTEEN

① (Close on Achilles' face, grave.)
 ⓐYes. You ~~resemble~~ resemble your sister.
 Achilles ⓑI could stop the war right now. ~~~~

② ~~(Close on Helen silent.)~~

② (Achilles looks at Helen, who looks right back at him.)
 ~~Helen: I claim the sanctuary of this altar.~~
 Achilles: I could snatch you right off that altar and take you straight back
 to Menelaus.

 ~~Helen: You'd violate this sanctuary?~~
 Helen: You'd dare to violate ~~this~~ sanctuary? ~~of the altar?~~ ~~I'd risk the gods' anger.~~
 the

③ ~~Weighed against~~ What can I lose? ~~~~ ~~~~ ⓑ ~~but then again, I'll just~~
 ⓐWhen I think of ? ⓑ ~~~~
 Achilles: ⓐ~~Weighed against all the sorrow it could save?~~ ~~I'll risk it.~~ ~~I could~~
 ~~wait -- you'll have to come down sooner or later.~~ I've already killed a son of the sun god.

 11/16/14
④ (Med close on Helen, frowning in anger and consternation & a little fear.)
 ~~Helen: You'd dare to violate this sanctuary?~~
 Achilles: ~~But then,~~ ⓐOr I could just wait -- you'll have to come down sooner
 or later.

⑤ (Achilles ~~walks~~ strides toward altar, reaching out for Helen. She shrinks back.)
 Achilles: ~~But that wouldn't show~~ ~~bravery or~~ ~~~~. ~~Not glory in that.~~ ~~So.~~
 ~~I don't~~ But there's no glory in that, so ...

⑥ (Achilles ~~stops & slams palm against his head.~~)
 hesitates, uncertain.)
 ~~Achilles:~~

⑦ (Helen alert, confused.)
 Well?
 Helen: ~~What?~~

(1) Achilles: (a) It would ~~make no difference~~. ~~The war would still~~ The war will go on. Menelaus might be satisfied with ~~getting~~ you, but the others ~~Achaeans~~ want more.

(b). I want more.

Helen: More?

(2) Achilles: (a) I didn't sail to Troy for you. Or your husband. Or ~~the~~ his brother the High King.

~~(b). I sailed to win the everlasting glory promised to me by the gods~~

(b): The gods promised me everlasting glory ~~win~~ in battle before Troy's walls.
 ~~have~~ I'll win

(3) Helen: You don't think you'd win glory by leading me back to Menelaus?

~~Achilles: I'll only win it in battle before Troy's walls~~

(a) Wait.

(4) Achilles: (b) ~~~~ Is this a test? Some sort of trick? ~~Are you~~ Maybe you're a goddess ~~in disguise~~ disguised as Helen.

(c) ~~Some say Helen is in Troy. Others say Egypt.~~ ~~What would the daughter of Tyndareus be doing here on a lonely peak of Ida?~~

(a): No, I'm no goddess. She commands and I follow.

(b): She led me here.

(5) Helen: ~~The goddess led me here. Just as she led me away from Sparta.~~ ~~She led me here.~~ I don't know why she ~~led me~~ chose this place today -- maybe to ~~~~ encounter you.

The gods arranged this.

(6) Achilles: (a) I see it now. ~~This meeting was arranged by the gods.~~

(b): I told my mother that I must see you. She told me to sacrifice when I reached Ida's peak.

And here we are. Helen: Your mother told you?

(1) Helen: ~~Why did you want to see me?~~ ~~I suppose it could be...~~ Perhaps. This does seem almost like a dream. But This meeting does seem a bit dreamlike...

Achilles: ~~I wanted to see the latest justification for men's eternal need to battle other men.~~ I wanted to see that you actually exist. I wanted to know that I'm fighting for a real reason, not just an excuse fabricated by Agamemnon.

The gods have put into men's hearts an eternal need to battle other men. But I needed to know that I'm fighting for a real reason, not whipped up by empty words. Agamemnon. I needed to see that you exist for myself.

CONTD. ♦

I've been away from Troy, but Priam summons me back. If my return to Menelaus

won't stop the war

~~Priam has summoned me back to Troy.~~ But here I sit ~~on this mountain peak~~. One side of
this mountain faces Troy. The other ~~side~~ faces your fleet. ~~And I need to choose which way to go.~~ I came to ask
~~where Priam summons me and his son's bed waits for me.~~ the goddess which way to go.

No use coming back. It wouldn't stop the war. And Menelaus would ~~kill you.~~ have you put to death.

Menelaus?
 doesn't sound like who ~~once~~ was once
∧ That ~~isn't~~ the man I ~~knew~~ — the man ~~I once called~~ my husband∧ No more, it seems.

PAGE SEVENTEEN CONT'D.

~~PANEL (1) CONT'D.~~

① ~~Helen: And here we are...~~
②
③ Achilles: (maybe o.p.) ~~Helen~~ But some say ~~the daughter of Tyndareus~~ is in Troy. Others say in Egypt.
 This is neither. ~~I came here to ask the goddess which way to go.~~
 I've been away from Troy, but Priam summons me back.

④ Helen: One side of this mountain faces Troy ② ~~while Priam summons me and his~~
 ~~son's bed waits for me.~~ the other side faces your fleet. ~~I came to ask~~
 ~~the goddess which way to go.~~ I'm here to ask the goddess which way to go.

 actually
③ Achilles: No use coming ~~back~~ with me. It wouldn't stop the war. And ∧ Menelaus
 would have you put to death.
 called me his wife.
 Helen: ~~Death?~~ Death? That doesn't sound like the man who ~~was~~ once ~~my husband.~~
④ Achilles: The sons of Atreus say you're still Menelaus's wife.
 Helen: ~~Never~~. No. No more.
⑤ Achilles (a): My father Peleus once called my mother his wife.
 (b): ~~She said~~ ~~She left him — like you left your husband.~~ "no more," just like you. But she's daughter to
 the god.

⑥ Helen: Some call me daughter to the god, too.

CONT'D.
↓

PAGE ~~FIFTEEN~~ SEVENTEEN CONT'D.

(2) Helen: ~~Now you have~~. ~~Here I am~~. ~~So~~ And here we are.

(3) Achilles: ~~Yes. I see you. Yes.~~ ~~I see you here.~~ But ~~Some say~~ Some say ~~Helen~~ the daughter of Tyndareus is in Troy. Others say in Egypt. This is neither.

Helen: ~~Even as we speak, the goddess urges me back to Troy.~~ ~~Even as we speak, the goddess urges me back to Troy.~~ ~~That's~~ ~~Priam is~~ my father ~~.~~ One of ~~Priam's~~ his sons is my husband. The rest ~~are my brothers.~~ They ~~battle for me and for~~ ~~the rest of Priam's people.~~ Priam has summoned me back to Troy. He's my father now, and one of his sons is my husband.

(4) Achilles: The sons of Atreus say you're Menelaus's wife. ~~For a wife to desert her husband flouts the natural order of things.~~

Helen: Once ~~. But even at we speak, I feel the goddess coming to take me back to Troy.~~ Once I tread the path the gods have laid for me. No more.

(5) Achilles: ~~For a wife to desert her husband.~~ ~~Likewise~~ My father Peleus once called my mother his wife too. ~~she~~ ~~Finally?~~ she said "no more." But ~~A path that~~ causes so much pain and trouble? ~~Flouts the~~ she is daughter to the god and ~~should take a new~~ ~~second husband.~~ natural order of things.

~~Helen: You have called me goddess.~~ Some call me daughter to the god, too.

(6) Helen: (a) ~~I accept the blame for~~ ~~I've done, but~~ But that's not why I left Sparta. ~~No, the truth is more complicated.~~ ~~Son of Peleus,~~ the gods give each of us one path in life ~~Son of Peleus,~~ (b) What if you knew that by following ~~that~~ one path you'd betray everything you ever held dear? But by refusing ~~that path~~ that path you'd betray yourself?

Helen: Some call me daughter to the god, too.

(7) (Helen a): But that's not why I left Sparta. But she is daughter to the god and she will not take a new husband.

(b): What if...

~~Some call me daughter to the god, too.~~
~~But that's not why I left.~~

(8) Helen: What if you knew that by following one path, you'd betray everything you ever held dear? But by refusing ~~that~~ path you'd betray yourself?

AOB#54 by E. James Shanower 12/1/14 ~~15B~~

PAGE ~~SIXTEEN~~ EIGHTEEN ⑯

① (Achilles shocked.)

Achilles(a) I doubt I'll live long enough, but... ~~An~~ My two ^destinies ~~paths~~? How did you know?

 (b): I'd meet the challenge with courage. ~~And then~~ You are a goddess!

~~Helen(a) If~~ that day ever ~~comes~~ ^arrives, remember me.

 (b) ~~Now you~~ ~~ought to~~ ^should leave before the goddess ~~comes~~ to take me home

② (Achilles ~~so~~ sort of wakes from a dream state. ~~He picks up spear, any other belongings.~~)

Achilles: ~~Yes, I'll go~~ — I need to find a spot on ~~this~~ peak for a pyre to
signal Achaean victory when the war ends. Men ~~will was~~ will be here with axes
soon to cut logs for ^the pyre

③ (Achilles bows his head as he ~~backs away from Helen or altar.~~) (Achilles picks up spear + any other stuff)

Achilles: ~~Men with axes will~~ Farewell, daughter of Tyndareus. May ^soon
the goddess bear you gently home. ~~I better go.~~ My men ^will be here, with axes
~~soon~~ to cut logs for the ~~pyre~~ signal pyre. Don't let them find you here.

④ (Helen sort of scrambles down altar, beckoning Achilles to wait, ~~while he picks up spear + other belongings (if any)~~)

Helen: Wait! ~~Wait!~~ My ~~brothers~~ — Kastor and Polydeukes — if they're ~~Not~~
with the Achaeans at Troy, where are they?

⑤ (Achilles stops + turns to her questioningly.)

Helen: ~~My brothers~~ If Kastor and Polydeukes ~~if they~~ ^aren't ~~not~~ with the Achaeans
at Troy, where are they?

⑥ (From behind Helen in foreground we see Achilles, a bit small, in background.)

Achilles(a) I don't know. But if they ~~ever~~ ever ~~$~~ come to Troy, the
war ~~would~~ ^will quickly be over.

 (b) ~~Farewell.~~

to meet my men, who'll be here soon with axes to cut logs for the signal pyre.

PAGE ~~SEVENTEEN~~ NINETEEN

① (From behind Helen we see Achilles retreat B among the trees. Shadows of trees fall over him, making him mostly or all silhouette.)

② (Helen sits on altar, B sad & depressed.)

Helen: Oh, gods.

③ Helen: ~~Where are they?~~ Where are they? Are they too ashamed ~~to fight for me?~~ Do they want to forget they ever had ~~a sister like me?~~ ~~The~~ for a sister? a sister named Helen?

④ Helen: (a) They loved me when I was little. Kastor would ~~set me~~ give me the reins of his fiercest team ~~horse~~ and laugh (b) And Polydeukes ~~was teaching~~ taught me to swim in the Eurotas river -- holding me up ~~to I wouldn't sink to keep me from sinking~~ when I'd start to sink.

(c) THEY ~~CAME~~ RAZED APHIDNAE WHEN THESEUS HID ME ~~THERE.~~

⑤ (Helen breaking down.)

Helen: ~~But now~~ Or have they followed mother?...

⑥ (Helen clutches herself, crying, burying her head in her arms as she crouches on the altar.)

Helen: ... oh, goddess...

PAGE ~~EIGHTEEN~~ <u>TWENTY</u>

(1) (In the background Helen sits weeping on the altar. In the foreground, in silhouette, Oenone + Korythos peek out at her from among the trees and bushes, hidden from Helen's ~~sight~~.) Korythos is 6 years old.

(o.p.) Korythos: ~~Who is sto~~ ∧ Mommy? Why is that lady crying on the altar,

(o.p.) Oenone: Shhh.

(2) (Oenone grits her teeth, overcome with anger.)

Korythos: ~~But~~ Who is she?

Oenone: You heard the man, Korythos- the daughter of Tyndareus.

~~(Oenone stuffs her anger down inside- she's barely holding it together.)~~

Korythos: ~~But~~ Who's that?

Oenone: Never mind.

(3) (Korythos is confused by his mother's unexpressed emotions just under the surface.)

Korythos: ~~Do you know her? B But~~ Why don't we go and ~~speak to her? Don't we~~ I'm hungry. Why aren't we ~~need to~~ collecting today's offerings? ~~I'm hungry.~~ Is it because of ~~that~~ crying lady?

(4) (Close on Oenone, a tear spilling from one eye) Korythos (o.p.): Mommy?

(5) (Oenone huss Korythos hard. He squirms a little.)

Oenone: Oh, ~~darling,~~ darling, ~~Korythos~~ -- don't ask ~~me~~ questions about her-- ~~Korythus--~~ ~~her. I won't be about able to contain myself. She's evil, evil, evil-- ~~that that--~~

Korythos: Mommy-- stop squeezing.

(6) (~~Oenone is crying.~~ She turns away from the altar. leading Korythos by the hand. ~~They~~ She means to sneak away)

Oenone: Come ∧ Korythos-- ~~come away from here.~~

(7) (Korythos steps on a branch, which snaps.)

SFX: <u>SNAP!</u>

AOB #34 by ERIC SHANOWER 11/17/14 (19)

PAGE ~~NINETEEN~~ TWENTY-ONE

① (Med close on Helen, turning her head sharply at sound of branch snapping.)
Helen: ~~What's that?~~ (thought): What was that?

② (Helen springs up from altar in a panic.)

③ (Helen runs among the trees.)

④ (Helen runs to guard, who's immediately alert.)

~~Helen:~~
~~Guard: Daughter of Priam?~~
~~Helen: Quiet~~

⑤ (Helen ~~too~~ continues down slope, signalling guard to follow, which he does.)
Helen: Quiet! We've got to get away from here. ~~These are~~ Achaeans ~~on the~~ with axes are coming. ~~mountain~~ close by. ~~I heard them.~~
Guard: ~~What~~? So close?

⑥ (Helen + guard ~~each~~ in foreground. Group of Trojan women with babies + attendants still on blankets in shade in background.)

Helen: Great Queen? – Aithra -- everyone! We need to ~~leave~~ go. ~~Now~~
Guard: Quickly!

⑦ (Long shot. Women, babies, servants, chariots + horses descending other side of mountain.)

AO3 #34 PAGE TWENTY-FOUR 12/18 REVISED
 ~~NOT ISSUE~~

① (Dbl-pg panel. Ach, Pat, & their men landing on beach in Achaean Camp. Ag, Od, + maybe Pal greet them. Men unloading grain joyfully from Ach's ships.)

Caption: Days later. The Achaean Camp.

Ach: ,,Absolutely, High King. TRlephus promises to supply all the grain we need.

Pat: The fields of Mysia can feed the army for years.

POL: THE SON OF PELEUS HAS SAVED THE MEN FROM STARVATION. ~~SO.~~

② (Inset panel. Pal. announces while Ag Sulks.)

Pal: ~~The son of Peleus has saved the men from starvation.~~ You'll hold a feast in ~~for his~~ the honor, won't you, ~~Agamemnon?~~ Son of Atreus?

Ag: Er, of course, Palamedes— I was about to say so.

③ (Half pg panel. ~~Trojan Throne Room.~~ NOT THRONE ROOM -- SITTING ROOM FROM ISSUE #22 - 1/17/19 Priam on throne w/ royal family gathered around. Priam dandling Hippothous on knee. Hecuba stands directly before Priam. Polyxena is pouting. No Kassandra.)

Caption: And in Troy.

Hecuba: ,,Yes, we're back safely -- with three new princes to add to ~~yf~~our family.

Priam: Ah, little Hippothous, you'll grow up into a mighty warrior like your brothers. I see that already.

④ (Inset. In foreground Andromache smiles at Hektor, who is solemn. In background 2) Priam announces.)

Priam: ~~From now on all royal children will be born safely there is Troy. How did your ere mother extract my permission persuade me to let you go traipsing across over the countryside?~~

From now on all royal children will be born ~~safely~~ here in Troy.

Andromache (whisper): Seems You were right, Hektor, my love.

HOW DID YOUR
MOTHER EVER EXTRACT
MY PERMISSION TO GO
TRAIPSING/OVER/THE
COUNTRYSIDE?

BARBARA RANDALL KESEL

Barbara Randall Kesel came into comics with strong points of view, ones that are well-informed, well-stated, and which she eagerly shares. She broke into the field as the result of a ten-page letter that she weote to DC Comics' legendary inker-turned-editor, Dick Giordano, taking a keen look at the portrayal of women in comics. From there she went on to become a writer and a Harvey Award-winning editor, doing work not just for DC, but for Dark Horse, Marvel, Image, and the industry supernova that was Crossgen.

Keep an eye on Barbara's panel descriptions, on how they go light on specific physical description of characters and action but focus more on the emotional aspects of what the characters represent, what they're going through, and how the reader will perceive them. You could give this same script to half a dozen good artists and get six stories that look totally different, but that clearly tell the same story and carry much the same impact.

– Nat Gertler

ECCENTRIC ORBIT

PAGE ONE

PANEL ONE: The TEACHER lines up her fifth-grade class for a quick photo. They're lined up against a classroom or hallway wall. It's back-to-school time, so everybody's in their new-school-year best. It's a public school with a mix of gender/race/wealth represented. We are focused on SIERRA, who is a suddenly-too-tall and rail-thin (Mixed-race? Maybe black/white, maybe some Indian blood—what would you like to draw?) girl with long braids. She seems to be all shoulders and feet and ears, maybe. I want her to be pretty enough but not a beauty, tall but not athletic (yet!). Just _distinctive_. Maybe she has a future in beach volleyball, but she's got a present where none of her parts work together.

SIERRA CAP: Funny thing happened over the summer…

TEACHER: LINE UP, EVERYBODY!

PANEL TWO: Sierra's a head taller than the rest, awkwardly tripping as she moves into position in line. The other kids look over and up at her in surprise and puzzlement—almost as if she had sprouted antlers.

SIERRA CAP: I grew.

FROM OFF: NOW ARRANGE YOURSELVES BY HEIGHT!

PANEL THREE: Sierra accidentally bonks a kid in the head with her elbow as she steps gawkily into line.

BONKED KID: HEY, WATCHIT, SCARECROW!

SIERRA CAP: But my coordination didn't.

SIERRA CAP: And the other kids didn't. Now I _tower_.

PANEL FOUR: The teacher is now taking the photo: all the kids are sort-of smiling; several have eyes to the side, looking at Sierra, the freak in their midst. Sierra has an awkward, apologetic smile.

TEACHER: MISS LEWIS WILL BE USING THESE PHOTOS TO CAST THE STUDENT PAGEANT.

SIERRA CAP: Mom says they'll catch up to me soon.

PANEL FIVE: Sierra looks outside at the beckoning road home, her head hanging to the side, a little shy and sad.

FROM OFF: I HOPE YOU'RE ALL READY TO PLAY YOUR PARTS WITH A SONG AND A SMILE!

SIERRA CAP: But will I ever catch up to me? I'm so awkward now.

SIERRA CAP: Except for when I'm out there…

PAGE TWO

PANEL ONE: Close on Sierra RUNNING home, her braids flashing behind. She's powerful and graceful at full speed—she's only awkward when she stops.

SIERRA CAP: I only feel good when I <u>run</u>.

PANEL TWO: A longer shot showing Sierra racing home, flying down the sidewalk with her backpack clutched in one hand. She wears an awkwardly-bright-tri-colored pair of racing sneakers that doesn't go with the rest of her outfit. Shoes that came from Sport Chalet and not a fashion store and are probably boys' shoes.

SIERRA CAP: Running is beautiful.

PANEL THREE: Sierra races up the front stairs into the house.

SIERRA CAP: Then my legs aren't too long, and I'm never tripping over my own body parts.

SIERRA CAP: I just <u>fly</u>.

PANEL FOUR: Sierra trips over the threshold and is headed for a sprawling landing on the floor inside.

SIERRA: WHUP!

SIERRA CAP: But when I stop…

SIERRA CAP: Everything's back to my new normal.

SIERRA CAP: <u>Stupid</u>.

PAGE THREE

PANEL ONE: Back in the classroom, different day. The Teacher is reading from a list. Sierra is leaning on her desk, fist to cheek, head to the side, trying to hunch shorter.

TEACHER: THE THEME FOR THIS YEAR'S PAGEANT IS "OUR UNIVERSE"!

TEACHER: HERE ARE YOUR ROLES…

SIERRA CAP: I don't like being different.

PANEL TWO: Star Number 1 smiles *sweetly* as her name is read. (Stars 1-3 all resemble each other in size and shape. Stylish cuteness.

FROM OFF: NAOMI WILL BE A <u>STAR.</u>

PANEL THREE: Star Number 2 smiles *shyly* as her name is read.

FROM OFF: JENNILYNN WILL BE A <u>STAR</u>.

PANEL FOUR: Star Number 3 smiles *sneakily* as her name is read.

FROM OFF: AND HEATHER WILL BE A <u>STAR</u>!

PANEL FIVE: Twin boy "asteroids" energetically fist-bump each other.

FROM OFF: BEN AND KEN ARE <u>ASTEROIDS</u>!

TWIN ONE: VERY!

TWIN TWO: WERY!

TOGETHER: <u>KEWL</u>!

PANEL SIX: Longshot of the classroom as Sierra leans toward the teacher, waiting to find out her fate.

TEACHER: AND, LAST BUT NOT LEAST…

TEACHER: <u>SIERRA</u>!

SIERRA CAP: I really don't want to stand out as weird.

SIERRA CAP: But I can't help it— I just <u>do</u>.

PAGE FOUR

PANEL ONE: Sierra's looking like she just got gut-punched. This does NOT sound like a good assignment.

FROM OFF: YOU'LL BE OUR BLAZING <u>COMET</u>!

SIERRA: (SMALL) comet.

SIERRA CAP: Comet? Maybe that's going to be okay.

PANEL TWO: Several of her classmates point and laugh. Mostly boys, but some not. Sierra's face has fallen and she's in shock, trying not to cry. KID #1 has a backpack and is miming puking into it. KID #2 is very short and looks up at her. KID #3 wears a tophat and glasses: the look should be stylish but smart.

KID 1: COMET! LIKE <u>VOMIT</u>!

KID 2: BAD LUCK, GIRAFFE! JUST LIKE YOU!

KID 3: PSST!

SIERRA CAP: Or maybe not.

PANEL THREE: Close on Sierra's wounded expression as she's circled by giggling kids (they're not trying to be cruel, just funny. They don't actually hate her the way she imagines they do, so don't make them look evil, just… kid-like). Kid #3 is gesturing, making a sweeping arc followed by a speed line that suggests he's whapped her butt and his hand is arcing upward, tracing her height.

KID #3: SOME COMET! ALL TAIL, NO COMA.

KID #4: COMA! SHE'S COMA GIRL!

SIERRA CAP: <u>Very</u> not.

PANEL FOUR: Oblivious, the Teacher spritely waves them all out of the classroom.

TEACHER: REHEARSALS AFTER SCHOOL TOMORROW!

SIERRA CAP: This is... awful.

PANEL FIVE: Sierra drags herself down the hallway. She's drooping down, her backpack hanging from her fingers. <u>Dejected</u>.

SIERRA CAP: I wonder if there's a way to get out of it.

PAGE FIVE

PANEL ONE: Kids file onto the elementary school stage as the announcement comes from the overhead speakers. The stage has two stairways off the front lip that lead to aisles in the audience.

SPEAKERS (elect.) GRADE FIVE, MISS HEFFERN'S CLASS!

SIERRA CAP: I just want to feel normal.

PANEL TWO: The DIRECTOR, a mini-Napoleon who teaches fourth grade but longs to be a rock star, indicates that Sierra should come out to the front of the stage. She's taking a step forward, her head down, shoulders slumped.

DIRECTOR: YOU, COMET, OVER HERE.

SIERRA CAP: But, no… singled out again.

PANEL THREE: The Director points off stage, indicating the aisles through the audience. Sierra is listing left, trying to look as small as possible, but is the same height as the teacher.

DIRECTOR: YOU'LL MAKE YOUR ENTRANCE FROM STAGE RIGHT, RACE THROUGH THE AUDIENCE AND CIRCLE BEHIND, BACK UP ON STAGE OVER HERE, THEN OFF ON STAGE LEFT.

DIRECTOR: RUN AS FAST AS YOU SAFELY CAN.

SIERRA CAP: I feel so stupid…

(Note: "stage right" is from the POV of the actors, so that's the side on the audience's left, and vice-versa. If you need to change the side to suit the art, make a note for the letterer to change the wording.)

PANEL FOUR: Sierra's head jerks up, her shoulders straighten. She looks even taller than usual, almost heroic. Kids behind her are giggling, snickering, pointing.

KID #1: HAVE A NICE <u>TRIP</u>!

KID #2: EXPLODING COMET! <u>WHOOOSH</u>!

KID #3: THIS WILL BE <u>EPIC</u>!

SIERRA CAP: Wait…

SIERRA CAP: <u>RUN</u>???

PANEL FIVE: Performance day! Just offstage in the wings, Sierra's hanging her head down again like in panel two. She's in black leotards/tights—a nothing of a costume topped and overloaded by a nearly-ridiculous "comet" headdress with silvery tinsel tail tendrils hanging down down. She *is* wearing her special comet shoes: bright chartreuse green running shoes with gaudy orange laces. She's got a secret smile curling her cheek.

The other kids are pointing and snickering. The star girls look adorable, and they wear pretty star dresses. The planets, asteroids, space station—they all look cute.

SIERRA CAP: Maybe they'll be surprised.

SIERRA CAP: Because when I run…

PAGE SIX

PANEL ONE (SPLASH): Sierra fills the page, caught in mid-stride as she races across the stage toward the audience, her glittery headdress leaving a shiny comet trail in her wake. Sierra's got a look of pure happiness on her face. A spotlight hits her, sending a spray of multi-colored light beaming. She looks happy, powerful, and beautiful. The cute little stars are staring, mouths open. The other kids are in awe: one moon elbows the "spaceman" next to him. She just went from freak to phenomenon.

SIERRA CAP: …it's <u>beautiful</u>.

I've been writing and drawing comics for years, but **The Dire Days of Willowweep Manor** was my first graphic novel script. My friend Christopher Baldwin came to me with an idea for a story about a girl who is transported to a world of Gothic literature and asked me to develop a complete script for him to draw. We brainstormed ideas and characters, we worked out a plot outline, and eventually I wrote the script.

When I'm plotting a comic, I always draw thumbnails. They don't need to be detailed; the important thing is to lay out the page and make sure the action is visually coherent. Even in a simple comic strip, it helps to see where the characters are relative to each other and how the word balloons need to be ordered. Once I've sketched a thumbnail, I can write the corresponding script.

In the script, I keep descriptions simple. Unless there's a specific layout or effect I have in mind, I trust the artist's visual imagination, and I love to see what they come up with. Though I draw solo comics too, I love the collaborative experience of working an artist or a writer to develop something neither of us would create on our own. My use of sound effects comes from years of working as a manga editor; other writers may want to write FX differently.

In this excerpt from the opening of **Willowweep Manor**, I knew Chris would come up with great designs for Haley's teacher and classmates, so I left the script open for him to draw whatever types of characters he wanted. We'd already settled on Haley's design, so we both knew what she would look like. I sent Chris my thumbnails for reference but emphasized that he didn't need to copy my layouts. He came up with some cool ideas I wouldn't have thought of, like having the panels curve downward when Haley jumps off the bridge. Chris built Willowweep Manor itself as a 3-D computer model to keep the architecture consistent, and a lot of the story takes place in and around the manor to take advantage of the model.

These days, my system for scripting a graphic novel is to write a rough outline, about two pages long, and then develop the script a few pages at a time. I thumbnail two or three pages, then script action and dialogue from the thumbnails, then thumbnail a few more pages, and keep going until I've written an entire book. It's kind of like using the Marvel Method with myself. This may not work for

everyone, but for me it breaks the book into manageable chunks and keeps the art and the writing from drifting apart.

My scripts are written in a lazy approximation of standard screenplay formatting. I don't really align the elements of the script correctly, but I'm pretty sure everything looks clear to the artist. No one has ever complained, so don't worry too much about formatting. As long as the script is clear, it can be written out in any way you like.

You should thumbnail, though! Comics are visual. Always think about how your writing will look on a page.

–Shaenon Garrity
November, 2021

EDITOR'S NOTE: The script and the thumbnails were delivered to the artist as separate documents. In this book, the pages are interspersed to make it easier to compare the scripted page to the related thumbnail.

Willowweep Manor

Concept and Art by Chris Baldwin
Script by Shaenon K. Garrity

PAGE 1

PANEL ONE

A flash of lightning against a dark, stormy evening sky.

<div align="center">

FX/LIGHTNING
FWSH

HALEY (off-panel)
A dark and stormy night!

</div>

PANEL TWO

In the rain, autumn leaves blow past a shadowy old building.

<div align="center">

HALEY (off-panel)
Through windswept torrents I come, seeking my inmost heart's desire.

</div>

PANEL THREE

Closer on one of the lighted windows of the building.

<div align="center">

HALEY (off-panel)
My thirst is unslaked by the disconsolate storm; my need burns through the autumnal chill.

</div>

PANEL FOUR

Close on HALEY. She holds up a sheaf of papers. A prominent **D+** is written across the top page.

<div align="center">

HALEY
PLEEEEASE can you reconsider my grade?

</div>

PANEL FIVE

Pull out. Haley is in a high-school classroom, evening. Her TEACHER sighs at her from across her desk.

Haley dresses as close as she can to her idea of a romantic heroine, given the limitations of the local Buffalo Exchange. At her side are her backpack and a pile of books.

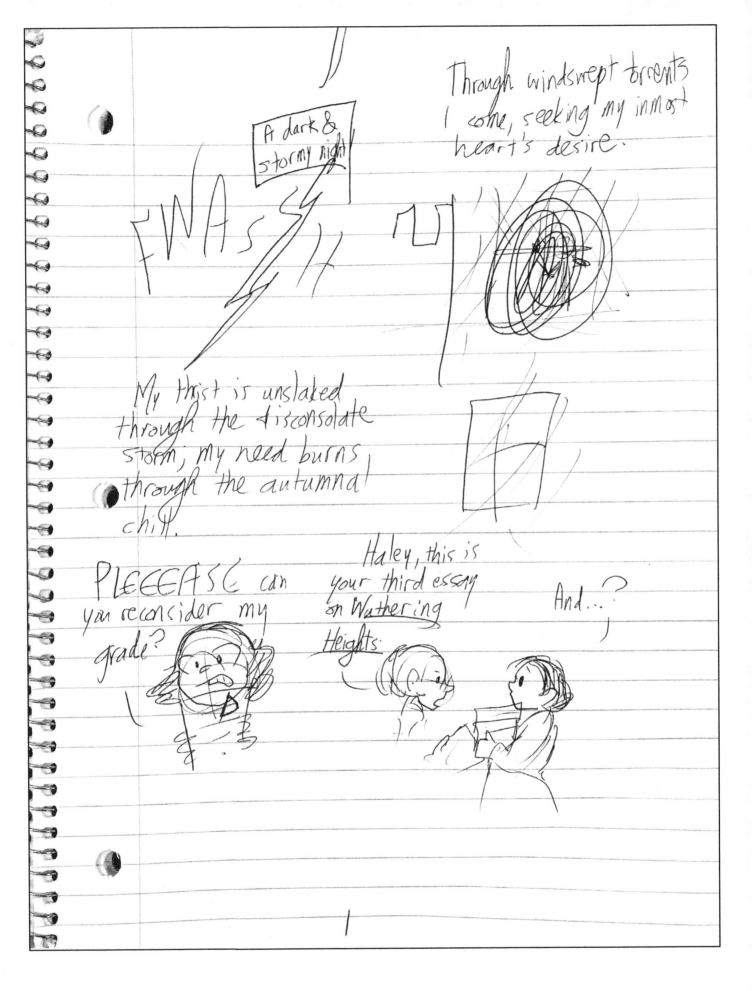

<p style="text-align:center;">TEACHER

Haley, this is your <u>fourth</u> essay on Wuthering Heights.</p>

<p style="text-align:center;">HALEY

And…?</p>

PAGE 2

PANEL ONE

Haley picks up the pile of books. They all have titles like History of the Gothic Novel and The Romantics: Attractively Tubercular and Post-Doctorates in the Attic: On a Feminist Theory of Gothic Romance and Brooding in Theory and Practice.

<p style="text-align:center;">TEACHER

I made it clear. This time you were to report on a <u>different</u> book.</p>

<p style="text-align:center;">HALEY

So…</p>

<p style="text-align:center;">HALEY

Jane Eyre?</p>

PANEL TWO

<p style="text-align:center;">TEACHER

No Jane Eyre. No Castle of Otranto. No Castle of Wolfenbach. Actually, nothing about a castle.</p>

<p style="text-align:center;">TEACHER

For a well-rounded education, you need to read something that <u>isn't</u> a Gothic romance.</p>

PANEL THREE

Haley gets dramatic.

<p style="text-align:center;">HALEY

But romances are so…romantic! The darkness! The crinolines! The handsome surly men!</p>

<p style="text-align:center;">HALEY

Surely you sympathize. You're surly.</p>

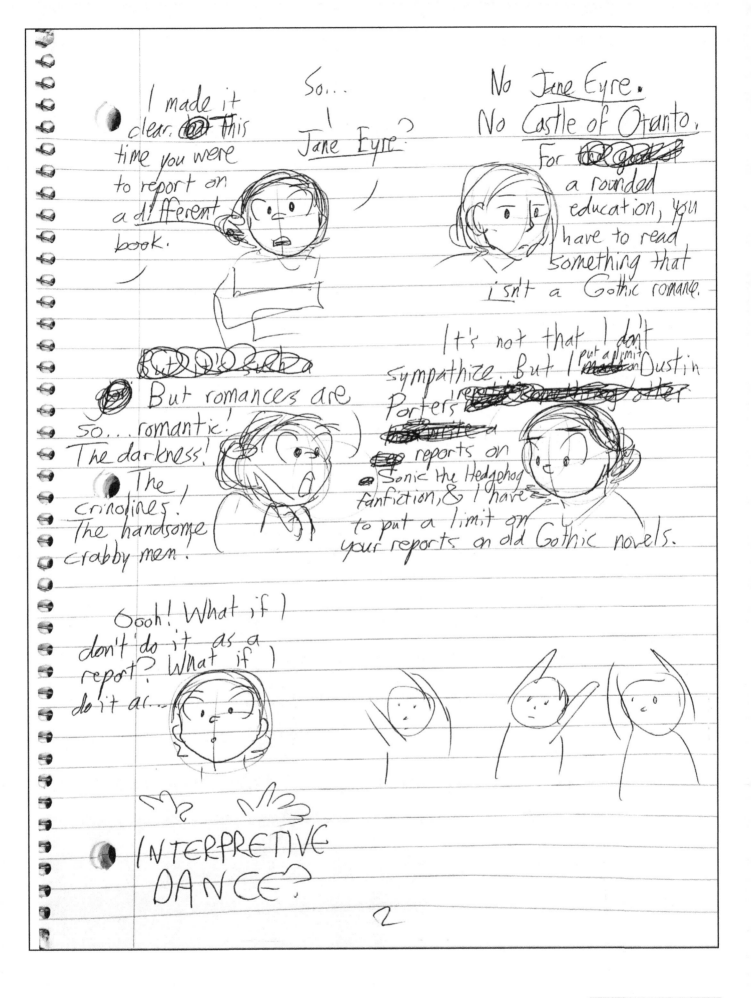

I made it clear. ~~But~~ This time you were to report on a different book.

So... Jane Eyre?

No Jane Eyre. No Castle of Otanto. For ~~the gothic~~ a rounded education, you have to read something that isn't a Gothic romance.

But romances are so... romantic! The darkness! The crinolines! The handsome crabby men.

It's not that I don't sympathize. But I ~~put a limit~~ Dustin Porter ~~~~ reports on Sonic the Hedgehog fanfiction, & I have to put a limit on your reports on old Gothic novels.

Oooh! What if I don't do it as a report? What if I do it as...

INTERPRETIVE DANCE?

2

TEACHER
I put a limit on Jordan Cho's reports on Sonic the Hedgehog fanfiction, and I have to put a limit on your reports on old Gothic novels.

PANEL FOUR

Haley drops her books, selling this idea hard.

HALEY
Oooh! What if it's not a report? What if it's…

HALEY
INTERPRETIVE DANCE.

PANELS FIVE-SEVEN
Haley does willowy dance moves from the Kate Bush "Wuthering Heights" video. Probably the swaying thing at the end.

PAGE 3

PANEL ONE

The teacher is unimpressed.

PANEL TWO

TEACHER
A new book report by Monday. <u>Go.</u>

PANEL THREE

Haley turns to leave, backpack on and books in arms.

HALEY
Sigh.

PANEL FOUR

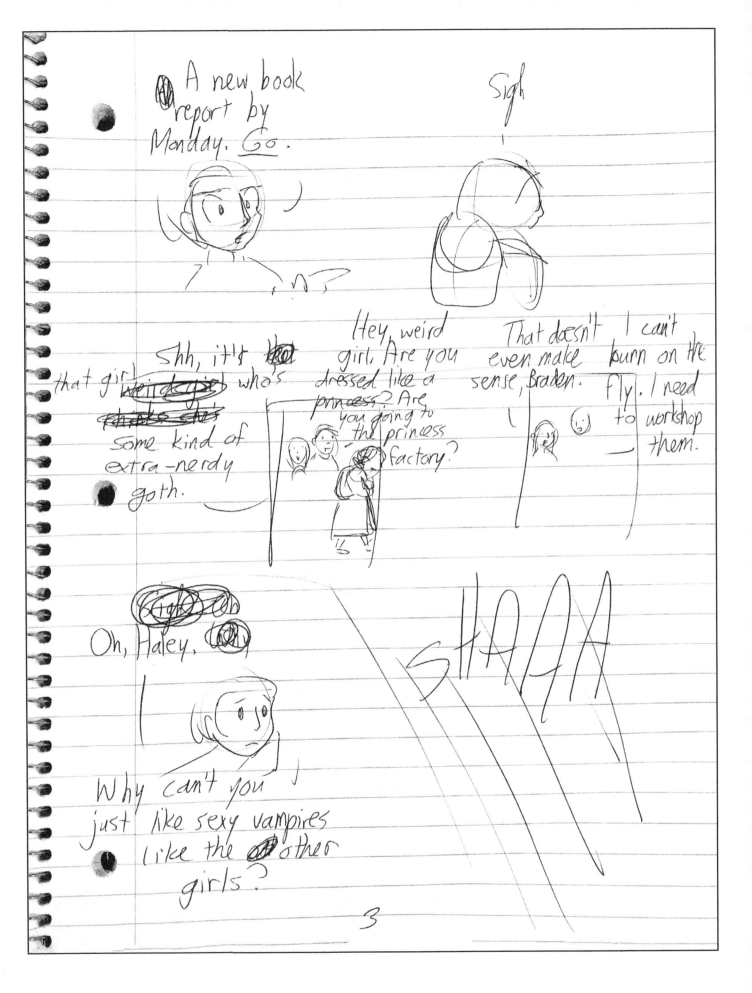

The teacher's view of the school hallway through her door. Haley walks past a pair of more normal teens, a girl and a boy.

<div align="center">

GIRL
Shh, it's that girl who's some kind of extra-nerdy goth.

BOY
Hey, weird girl. Are you dressed like a princess? Are you going to the princess factory?

</div>

PANEL FIVE

Same shot. Haley is gone, but the kids hang on.

<div align="center">

GIRL
"Princess factory" doesn't even make sense, Braden.

BOY
I can't burn on the fly. I need to workshop them.

</div>

PANEL FIVE

The teacher sighs yet again.

<div align="center">

TEACHER
Oh, Haley.

TEACHER
Why can't you just be into sexy vampires like the other girls?

</div>

PANEL SIX

Transition panel: rain. A dark and stormy night.

<div align="center">

FX/RAIN
SHAAAA

</div>

PAGE 4

PANEL ONE

Haley walks home in the rain, carrying her books and an umbrella, determined and actually pretty cheerful.

> HALEY
> Give it up, rain! You can't keep me from a night of glorious reading!

> FX/PUDDLES
> splish splish

PANEL TWO

Haley leans on the railing of a bridge. Her books sit beside her, with her umbrella propped over them.

> HALEY
> A proper Gothic heroine would stand wistfully in the rain and think of poetry.

PANEL THREE

Haley dramatically recites poetry.

> HALEY
> *Where the Northern Ocean, in vast whirls,*
> *Boils round the naked, melancholy isles—*

PANEL FOUR

Interrupting noise from below!

> FX
> SPLOOSH

PANEL FIVE

Haley peers over the side of the bridge to the water below.

> HALEY
> Is somebody down there?

PAGE 5

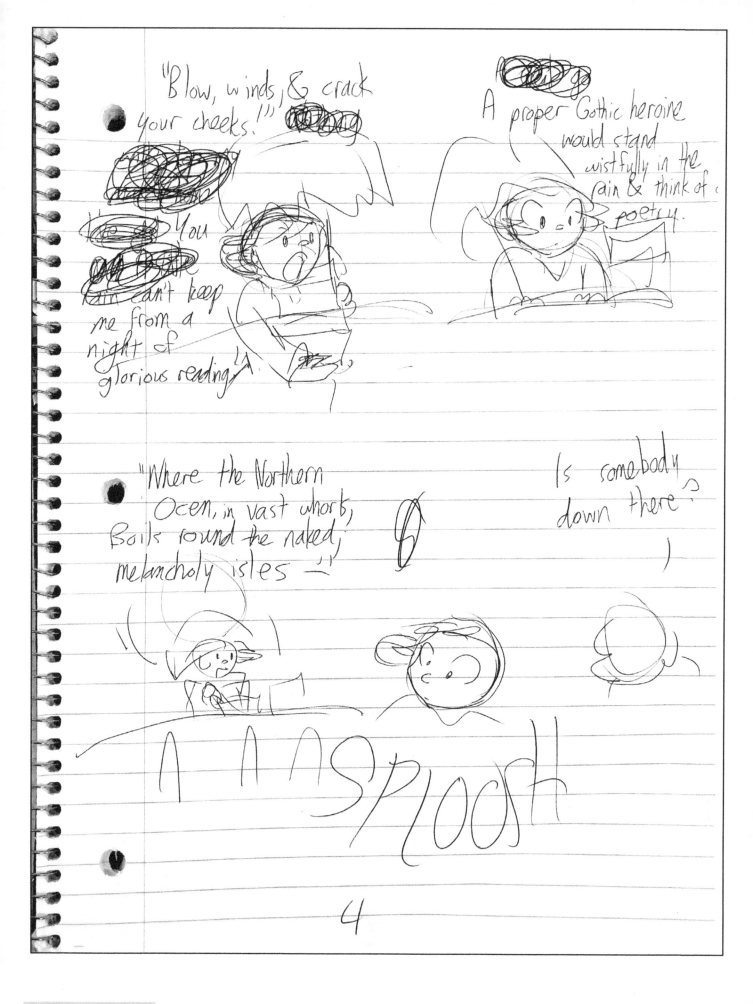

PANEL ONE

Large panel: Haley, looking down from the bridge, sees someone drowning in the river below.

 HALEY
 Oh!

 MONTAGUE
 glub

PANEL TWO

Haley climbs down the bank to the river, slipping in the mud.

 HALEY
 Oh! Oh! Oh!

PANEL THREE

Haley slips and falls into the river.

 FX
 SLIP

 HALEY
 Whoa!

 FX
 SPLASH

PANEL FOUR

Haley bobs up, spitting water.

 FX/HALEY
 pbbt

PAGE 6

PANEL ONE

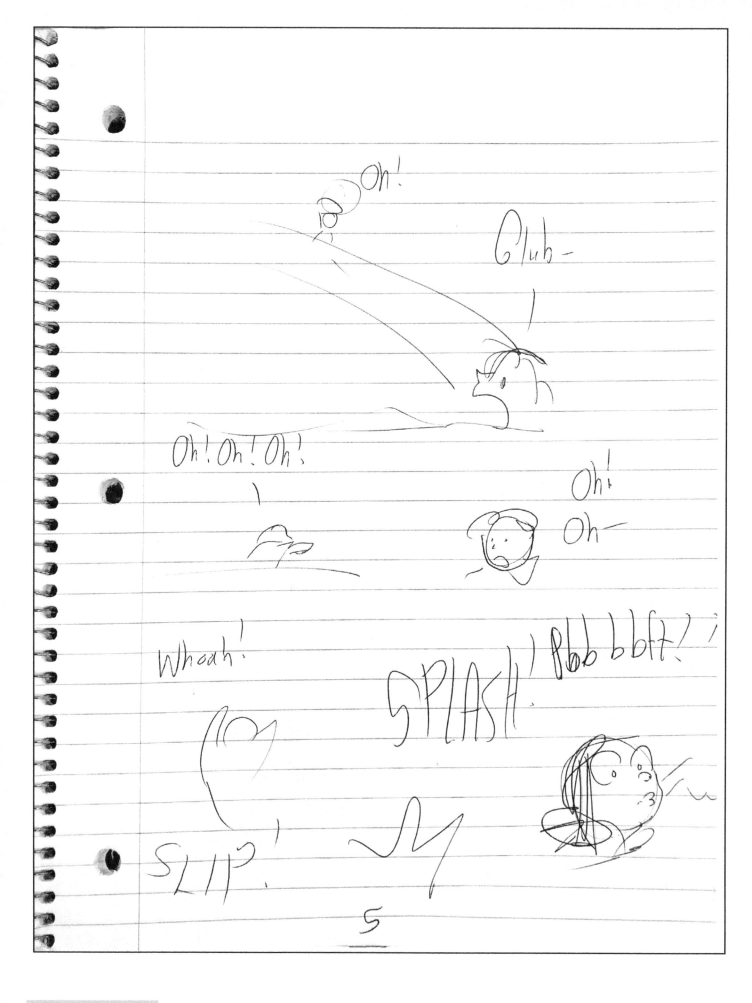

Haley grabs the drowning man, MONTAGUE, who does not seem grateful at all.

> MONTAGUE
> Get off me!

PANEL TWO

Montague struggles to swim free of Haley.

> HALEY
> I'm saving your life!

> MONTAGUE
> I'm fine! I can take care of mys—

PANEL THREE

He goes under.

> MONTAGUE
> —*blurg*—

> FX
> SPLOOSH

PANEL FOUR

Haley pulls him up again. He really does seem to need help.

> MONTAGUE
> *Gasp!*

PANEL FIVE

Haley pulls Montague onto her back. He reluctantly and crabbily complies.

> HALEY
> I was a camp counselor! Three summers!

> MONTAGUE
> Very—well—

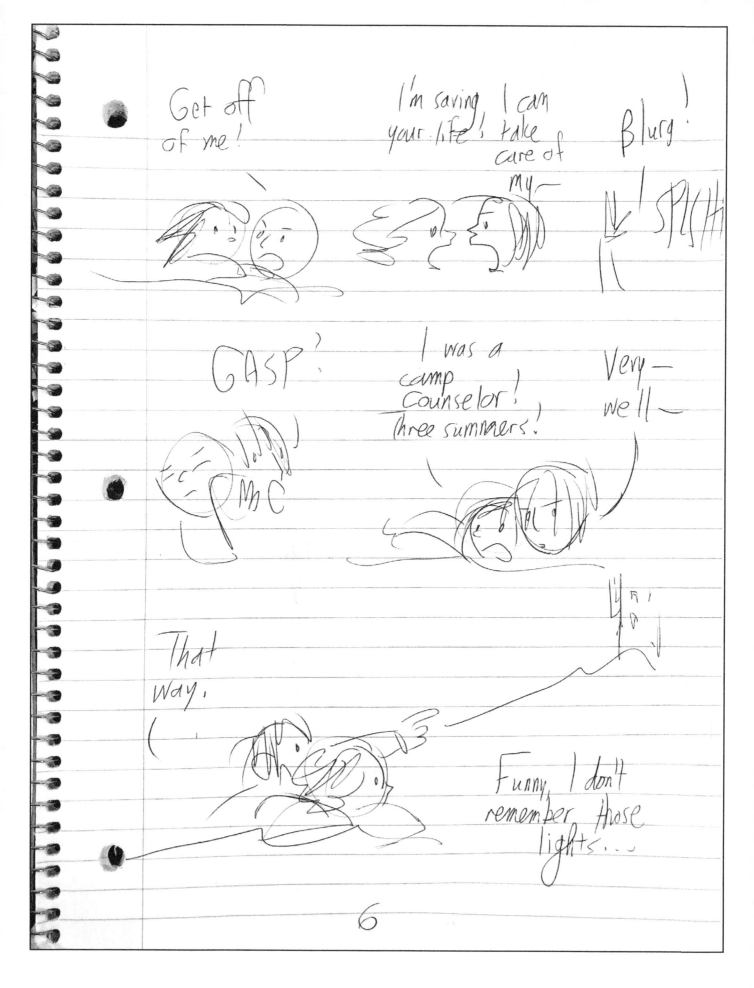

PANEL FIVE

Long shot: the two swim for a vast and peculiar gothic manor suddenly looming on the shore. Lights shine in the windows.

MONTAGUE
That way.

HALEY
Funny, I don't remember those lights...

PAGE 7

PANEL ONE

The rain is slackening now. Haley drags Montague onto a rock in the water. They're both exhausted. Montague spits water.

HALEY
blerg

MONTAGUE
pbbt

PANEL TWO

Close on Haley. She opens one eye.

FX/RAIN
drip drip

PANEL THREE

Big panel: a final flash of lightning illuminates Willowweep Hall on the nearby shore.

FX
FWASH

PAGE 8

PANEL ONE

Full-page image of the bridge at night. A few drops of rain falling. Haley's pile of books sits abandoned.

FX/RAIN
plip plip

PAGE 9

Chapter title page. Illustrate any way you like, after the Gothic style.

TITLE
1.
A Stranger Arrives.

PAGE 10

PANEL ONE

Dawn. Haley lies alone on the rock, unconscious. A few gulls circle overhead.

FX/GULLS
kree kree

PANEL TWO

CUTHBERT and LAURENCE ride up on horseback.

FX/HORSES
Galumph Galumph

PANEL THREE

CUTHBERT
Look, brother, a maiden!

LAURENCE

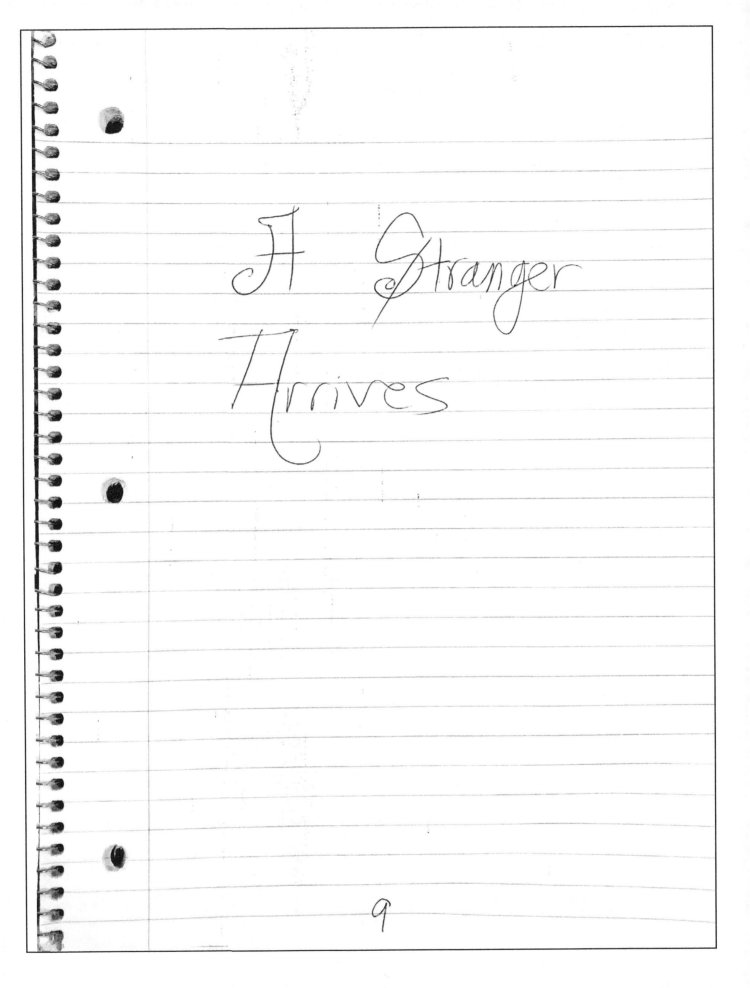

A Stranger Arrives

9

You can tell at this distance?

PANEL FOUR

Cuthbert dismounts, excited. Laurence is nonplused. He usually is.

> CUTHBERT
> I shall save her!

> LAURENCE
> We're supposed to be looking for—

PANEL FIVE

Cuthbert wades gingerly in to the shallowest part of the water.

> CUTHBERT
> Ooh, oh, *agh*, this is cold.

PANEL SIX

Cuthbert continues to not dive in.

> CUTHBERT
> Oop!

PAGE 11

PANEL ONE

LAURENCE, having dismounted, watches unimpressed from the shore.

> CUTHBERT
> I mean <u>really</u> cold.

PANEL TWO

More of the same.

> CUTHBERT

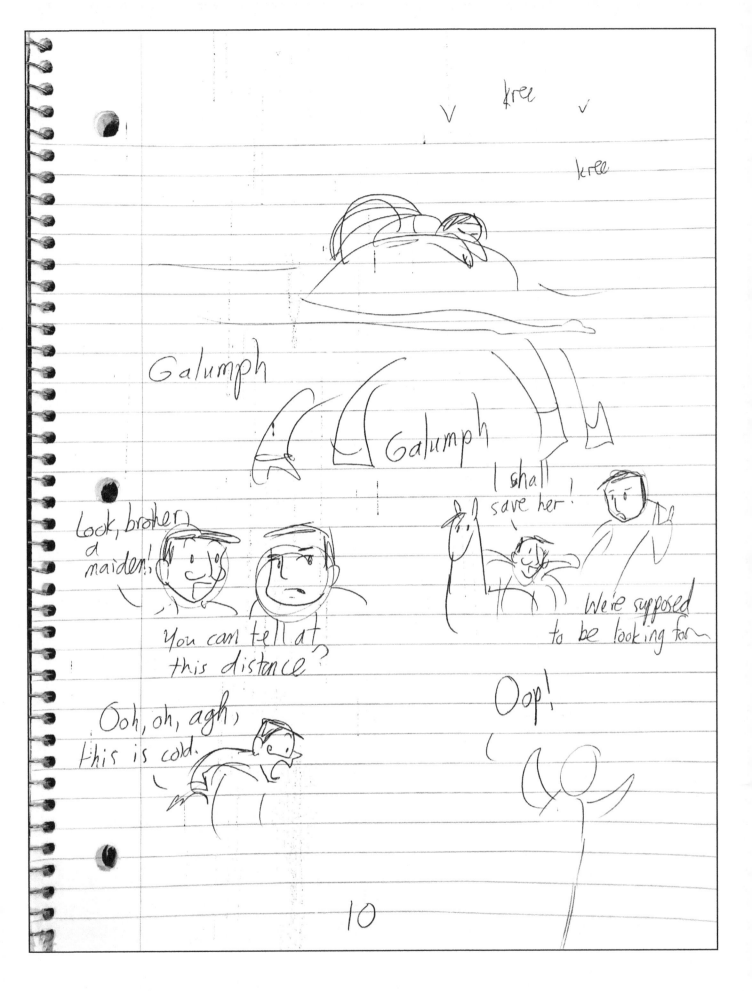

This is the worst part.

PANEL THREE

Cuthbert has waded ankle-deep into the river, still way, way off from the rock.

 CUTHBERT
 I'm going to do it!

 CUTHBERT
 Any second now!

 CUTHBERT
 Don't pressure me!

PANEL FOUR

Laurence wades swiftly past Cuthbert.

 LAURENCE
 Out of the way.

 FX/LAURENCE
 splish splash

PANEL FIVE

Laurence sinks into the water, his face impassive.

 LAURENCE
 I'm already miserable. What's being cold and wet going to change?

 FX/LAURENCE
 bloop! bloop!

PANEL SIX

Cuthbert, now safely on shore, calls after him.

 CUTHBERT
 Very well, but I want credit for the concept!

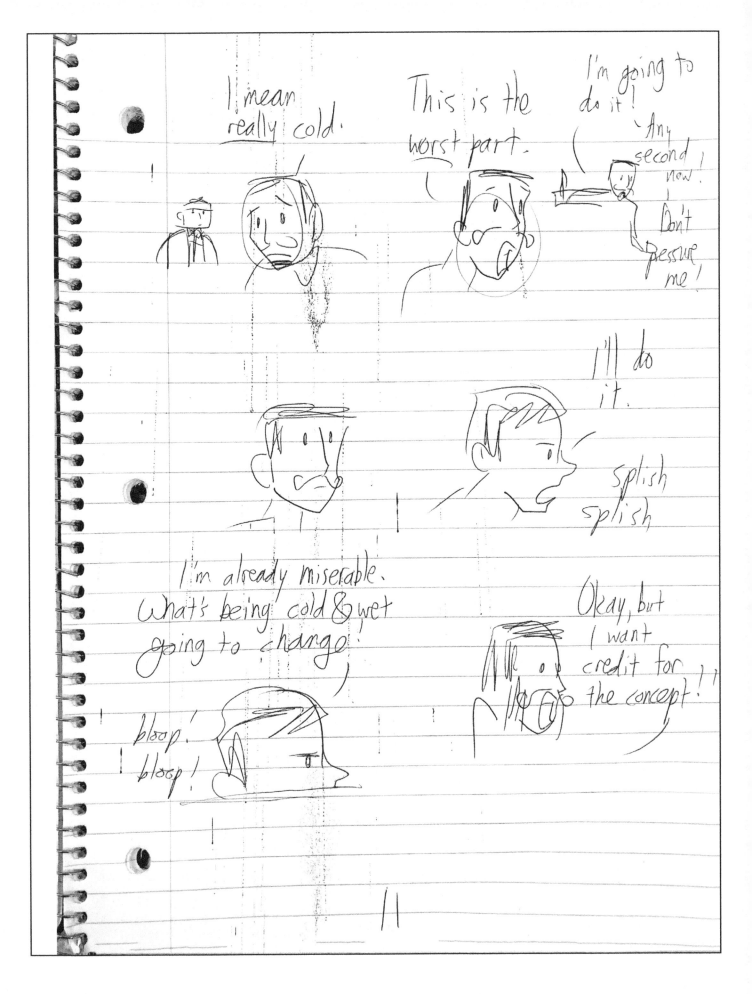

PAGE 12

PANEL ONE

Cuthbert watches from shore.

FX/OFF-PANEL
splsh splsh sploosh

PANEL TWO

Laurence, soaking wet, returns with the still-unconscious Haley draped over his shoulder. Cuthbert follows them like a puppy.

CUTHBERT
Let me carry her!

FX/LAURENCE
splish

PANEL THREE

Cuthbert, with Haley draped over his saddle, gallops happily off.

CUTHBERT
Fear not, maiden!

FX/HORSE
GALUMPH GALUMPH

PANEL FOUR

Laurence, soaking wet and not at all happy, watches them go.

LAURENCE
A visitor.

LAURENCE
Ugh. How?

PANEL FIVE

Long illustration along the bottom of the page: Willowweep Hall at dawn.

PAGE 13

PANEL ONE

Haley wakes up in a well-appointed Regency bedroom.

> HALEY
> *snnnrk...*
> Yes? Hello?

PANEL TWO

The dark and frightening figure of WILHELMINA, the housekeeper, looms overhead.

> FX
> LOOM!

PANEL THREE

Haley leaps up, terrified.

> HALEY
> YAUGH! A monster!

PANEL FOUR

Pull out to reveal that Wilhelmina is, although large, foreboding, and stern, an apparently human woman.

> WILHELMINA
> Calm yourself. I am Wilhelmina, housekeeper of Willowweep Hall.

PANEL FIVE

Haley sits back, relieved.

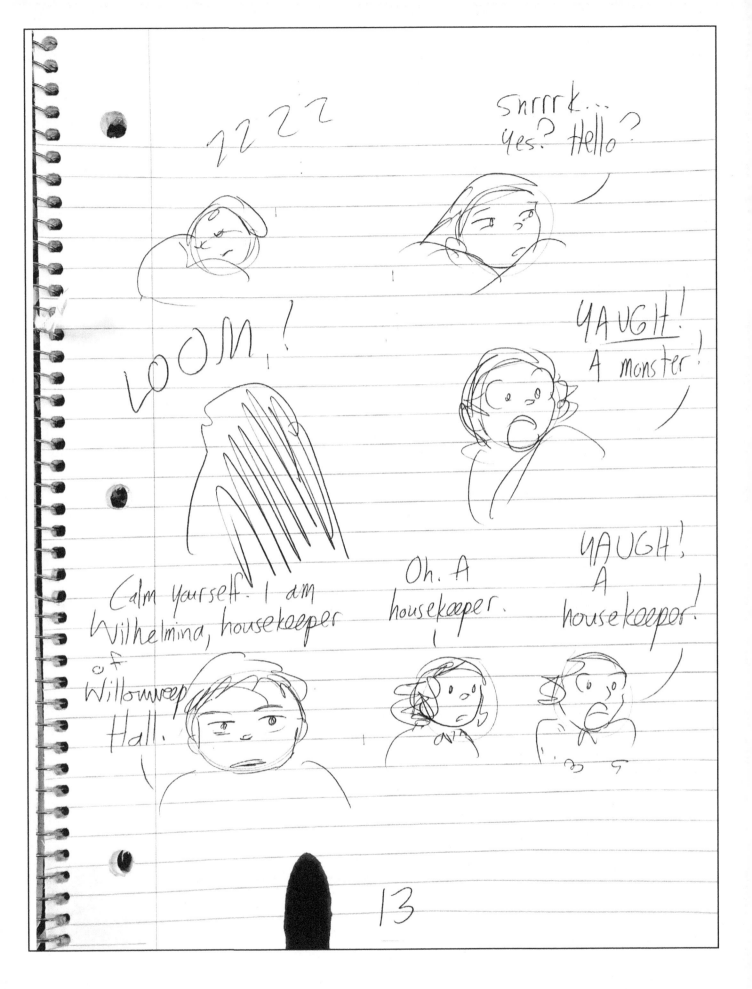

HALEY
Oh. A housekeeper.

PANEL SIX

Haley screams again.

HALEY
YAUGH! A housekeeper!

PAGE 14

PANEL ONE

Haley gets out of bed. Someone has dressed her in a lacy peignoir.

HALEY
I've read about this. You wouldn't be one of those foreboding housekeepers who rules the manor with an iron fist and secretly fondles the mistress's lingerie, would you?

PANEL TWO

Wilhelmina glares impassively.

PANEL THREE

Same.

WILHELMINA
The mistress is no longer with us.

PANEL FOUR

HALEY
You didn't answer my question.

WILHELMINA
Enough about me. You owe Master Laurence thanks for saving you.

PANEL FIVE

Cuthbert suddenly pops up from behind Wilhelmina.

CUTHBERT
Hellooo!

WILHELMINA
Although Master Cuthbert wants me to say it was him.

PANEL SIX

Haley frowns.

HALEY
No, wait. I rescued someone, not—

CUTHBERT
I did the rescuing! It was Cuthbert!

PANEL TWO

Haley tries to remember the previous night.

HALEY
I was on my way home from school...I heard a splash...

PAGE 15

PANEL ONE

HALEY
I mean, I'm happy to thank this Laurence person...

CUTHBERT
Thank me!

HALEY
...but where am I?

PANEL TWO

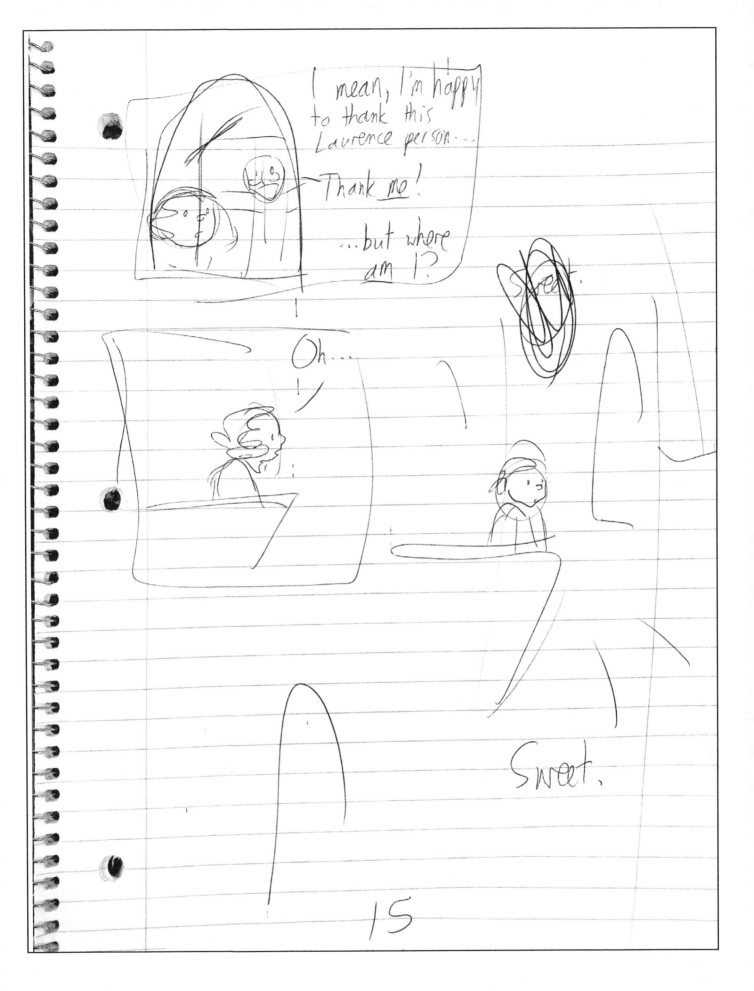

Haley opens a glass door, revealing blue sky.

 HALEY
 Oh...

PANEL THREE

Haley stands on a balcony. From here, she can see the walls of Willowweep Hall and the moors
stretching dramatically around it.

 HALEY
 Sweet.

When I started writing for comics I had never seen an actual comic book script, so I created my own, essentially a modified screenplay format. No one complained so I've stuck with it ever since, though I do dimly recall one company (I can't remember which one) sending out a memo encouraging writers to adopt their preferred script format. Which I promptly ignored.

I've always written full script, which means besides creating the captions and dialogue, I do detailed panel descriptions. I describe each character's look, their facial expressions, the backgrounds, basically whatever feels germane to telling the story. And I try to be as specific as possible. I learned early on, both in comics and screenwriting, that if you don't write it, it won't get into the story.

I also break down the number of panels on a page, pacing story and dialogue so the reader will be drawn from page to page. And it's important to "design" pages based on the content. For instance, action generally requires larger panels to be dynamic, so I make a point of leaving room in those sections for the artist to sing.

Needless to say, my scripts can get rather dense. Not Alan Moore dense, who famously could write an entire page of description for a single panel, but dense enough. I'd like to think editors and artists appreciate all the detail, though an artist once shared how he broke down my scripts, which was to highlight what he thought was important and ignore everything else. A lot landed in the ignore pile, but the artist did a fantastic job, so whatever works.

In terms of breaking down a story for script, for me it's an intuitive thing that comes from having read thousand and thousands of comics over the years. I'm usually told how many pages have been allotted for a story, so I'll start on page one, and as I write I'll get a sense of how best to pace a piece so it comes to a satisfactory conclusion. For most stories, I generally put together a short "beginning, middle and end" for myself so I have a road-map, then I'll write like the wind! Fortunately, it usually works out…

– **Mark Verheiden**
November 2021

Mark Verheiden

 Avenue,
Pasadena, CA. 91104
United States Of America
818/ -

THE AMERICAN
by Mark Verheiden

PAGE 1--

Panel 1: Tight close-up of our main character for this story, a guy named JERRY. He's staring into the "camera". Jerry's 35, maybe 40, with the look of a serious alcoholic. His hair is matted, sticky with sweat, and he hasn't shaved in days. While this should be a pretty tight close-up, note that Jerry's wearing a drab green flak jacket-- unbuttoned, so we can see his teeshirt underneath.

 This whole page should be dark, dark, dark. Light comes from a black and white television sitting on a chair at waist level in front of Jerry, so we can play with all sorts of cool highlights and such. Just make it dark.

CAPTION (Jerry): IT HAD BEEN RAINING ALL DAY-- ONE OF THOSE HEAVY, DRENCHING RAINS THAT SETTLES ON THE CITY LIKE A GRAY, LIVING THING.

CAPTION #2 (Jerry): I HADN'T LEFT THE APARTMENT FOR WEEKS.

Panel 2: Tighter angle of Jerry, lifting a service revolver from a nearby table and glancing at it ruefully. He's looking at the gun in his hand as if it were some kind of cancerous growth.

CAPTION (Jerry): IT'S FUNNY. WHEN YOU GET RIGHT DOWN TO IT, NOTHING REALLY MATTERS EXCEPT YOUR DECENCY.

BOTTOM CAPTION (Jerry): IF YOU HAVEN'T GOT THAT, YOU MIGHT AS WELL BE DEAD.

Panel 3: Reverse the angle, so we're looking over Jerry's shoulder toward a small black and white television perched on a chair in front of the desk. The picture is fuzzy, indistinct, but we're seeing the logo of the Cable News Network (CNN in the States). Reference available on request. It's a 24 hour news channel.

CAPTION (Jerry): THE DOCTORS SAID I SHOULD TRY TO WRITE IT OUT-- PURGE IT OUT OF MY HEAD. BUT IT NEVER MAKES MUCH SENSE.

CAPTION #2 (Jerry): MAYBE THAT'S WHY RUTH FINALLY LEFT ME-- IT NEVER MADE SENSE TO HER, EITHER.

1

<u>Panel</u> <u>4</u>: Move in closer on the TV. The CNN logo is gone, replaced by your standard "man behind a desk" talking head anchorman. Supered in the corner of the screen, to the right of the anchorman's head, is a small "designey" logo that is leading into their next news story.

CAPTION (Jerry): HE'S BEEN ON THE NEWS ALL WEEK-- JESUS, HE LOOKS JUST THE SAME.

ANCHORMAN: -- THE CONGRESSIONAL INQUIRY INTO THE MILITARY'S SECRET "AMERICAN" SQUAD HAS TAKEN A TURN WITH--

<u>Panel</u> <u>5</u>: Jerry is toying with the gun, scratching his chin with the barrel.
 If credits are going to be appearing in each separate A-1 story, this might be a good place for them in this piece.

JERRY: STILL THE BIG SHOT, AREN'T YOU?

JERRY #2: YOU DID ME <u>GOOD</u>, MAN.

2

Panel 1: We're cutting to a jungle scene in Vietnam (!). Jerry should be easily recognizable in these scenes-- though he's dressed in standard American military uniforms. We're following an Army outfit on a routine "recon" through a North Vietnamese landscape. There are maybe 8 or 9 guys visible in this sequence.
 Maybe less. Let's avoid the incorrect movie cliche of having all the soldiers bunched together (which makes them easy targets in real life, but easier to photograph in film). Jerry's our focal character, though, and he's basically on point. His rifle is nestled under his arm, ready for action. Jerry himself is terrified.

CAPTION (Jerry): I JUST CAN'T GET IT OUT OF MY HEAD. HOW LONG DO I HAVE TO PAY FOR WHAT I DID-- NO-- WHAT HE DID.

CAPTION #2 (Jerry): CHRIST, WE WERE JUST KIDS. I WAS BARELY NINETEEN-- NEVER EVEN BEEN LAID.

Panel 2: Tighter angle of Jerry, sweating under his helmet in the dense bush. We want to see real tension here.

CAPTION (Jerry): TEN WEEKS OF BASIC AND I WAS SUPPOSED TO BE SOME KIND OF JOHN WAYNE--

CAPTION #2 (Jerry): --WHEN ALL I WAS REALLY WAS SCARED TO DEATH.

Panel 3: The small platoon has gathered in a clearing, where they seem to be waiting for someone. Several of the men are looking toward the sky, shielding their eyes with their hands to protect against the hot sun. There are some officers waiting in the clearing with our footsoldiers, and they are quite snappy-- pressed uniforms, regulation caps, the works.

CAPTION (Jerry): THEY TOLD US TO HOLD AT A CLEARING ABOUT 3 KLIKS FROM A SPECK CALLED KHE CHOU. I CAN STILL REMEMBER THE HEAT-- THICK, LIKE A WOOL BLANKET.

Panel 4: We're looking up from the point of view of one of the soldiers (Jerry, probably) as an Army helicopter swoops out of the sky and prepares to make a landing.

CAPTION (Jerry): WE FIGURED THERE WAS SOME HEAVY HITTING TOURIST COMING IN FROM THE WAY THE OFFICERS WERE POLISHED UP-- LIKE THEY WERE PREPPING FOR THE SENIOR PROM.

3

Panel 5: The chopper has landed and much to the soldiers astonishment, THE AMERICAN steps out. He's in full costume and he's grinning, waving his arms over his head like he's just stepped out on stage. He's being followed by a cameraman with a shoulder mounted camera and a sound man with a cable connected, portable tape recorder and microphone. They're filming the AMERICAN's big entrance.

CAPTION (Jerry): --BUT JESUS-- I NEVER EXPECTED--

4

Panel 1: Angle of THE AMERICAN as he's "directed" by one of the cameraman, standing just outside the helicopter door, to "do it again." THE AMERICAN is standing on the skirt of the chopper, holding one of the choppers struts for balance and obviously trying to prepare himself for this performance. The cameraman, with a beard and Hawaiian shirt, is obviously less than military. We want to give THE AMERICAN's visit a real "Hollywood" sort of feel.

The other men, including Jerry, are watching dumbfounded from the sidelines, scratching their heads, adjusting their rifles, etc.

CAPTION (Jerry): I'D BEEN READING ABOUT HIM EVER SINCE I WAS A KID. HE STOOD FOR EVERYTHING I THOUGHT I BELIEVED IN-- COURAGE, HONOR--

CAMERAMAN: --YEAH, YEAH, THAT'S IT-- I WANT TO GET A SAFETY TAKE IN CASE THERE'RE ANY PROBLEMS--

AMERICAN (steadying himself): FROM HERE? IS THIS OKAY?

Panel 2: THE AMERICAN makes his triumphant appearance again, with the same wave and smile as before. The cameraman is backing away, taking it all in, grinning behind the camera's eyepiece. The soundman is beside him, aiming his shotgun microphone toward our hero.

CAPTION (Jerry): WHAT THE HELL WAS HE DOING HERE?

CAMERAMAN: GOOD, GOOD--- REAL NICE. THAT'S A TAKE.

Panel 3: The soldiers have been "lined up" in formation, standing at attention while THE AMERICAN "reviews" them, more or less. Jerry is one of the last in the reviewing line. All the foot soldiers look bedraggled and exhausted; they make a game effort to suggest enthusiasm, but it really doesn't work.

CAPTAIN: ALL RIGHT-- TEN HUT! SHOW OUR GUEST A LITTLE RESPECT!

AMERICAN: NEVER MIND ALL THAT, CAPTAIN-- I DON'T WANT ANY SPECIAL TREATMENT.

AMERICAN #2: I'M JUST ANOTHER GRUNT, LIKE THE REST OF THESE BOYS.

5 .

Panel 4: THE AMERICAN has stopped in front of one of the soldiers and he's pumping the kid's hand enthusiastically. The soldier is looking up at him with a "what the fuck?" expression-- he still can't believe his eyes. (Incidentally, from the perspective of historical accuracy, a lot of these soldiers should be black-- including this kid.)

CAPTION (Jerry): WHEN YOU GET RIGHT DOWN TO IT, WHAT THE HELL WAS VIETNAM BUT A PAIN IN THE ASS BLIP-- AN EXERCISE IN TACTICS--

AMERICAN: WHAT'S YOUR NAME, SOLDIER?

DONNELLY: CALVIN DONNELLY, SIR.

AMERICAN #2: DONNELLY. THAT'S A GOOD IRISH NAME.

BOTTOM CAPTION (Jerry): -- A CHANCE TO FLEX OUR COLLECTIVE MUSCLES AND JUSTIFY THAT EXPENSIVE WAR MACHINE.

Panel 5: THE AMERICAN has moved down the line and stands in front of Jerry, offering his hand just like with Donnelly.

CAPTION (Jerry): I MEAN, HELL-- WE WERE THE UNITED STATES MILITARY. WE HAD THE FIREPOWER AND THE BALLS TO KICK COMMIE ASS FROM SEA TO SHINING SEA.

AMERICAN: HOW ABOUT YOU, SON? READY TO KILL SOME OF THESE GOOK BASTARDS?

JERRY: YESSIR. ALL READY.

CAPTION #2 (Jerry): LIKE A BULLY IN A SCHOOL YARD.

Panel 6: Tight close-up of THE AMERICAN's eyes, seen through his visor/mask. He is squinting rather demonically, like he's psyching himself up for the firefight to come.

CAPTION (Jerry): YOU COULD SEE THE WHOLE GAME PLAN REFLECTED IN THE SON OF A BITCH'S EYES.

6

Panel 1: The company Captain has pulled Jerry and a couple of other men aside, whispering and cupping his mouth so THE AMERICAN can't hear. THE AMERICAN himself is somewhere in the background, striking a heroic "observer" pose while the cameraman rolls on.

CAPTAIN: ALL RIGHT, LISTEN UP. THEY WANT TO GET SOME SHOTS OF THEIR BOY MAKING FRIENDLY WITH THE VILLAGERS AT KHE CHOU.

CAPTAIN #2: INTELLIGENCE SAYS THE VILLAGE HAS BEEN CLEARED, BUT IF ANY SHIT COMES DOWN, LAY DOWN SOME HEAVY COVER AND HOLD TIGHT UNTIL HIS ASS IS OUT OF HERE.

Panel 2: THE AMERICAN is taking point, leading the platoon down a jungle trail. The heroism of his taking the most dangerous position is somewhat blunted by the fact that he's still being followed by that cameraman. While the other soldiers are still huddled over in scared, "protect my ass" positions, THE AMERICAN is standing bolt upright, chest out, wading into the brush like some sort of automaton.

CAPTION (Jerry): HE TOOK POINT AND WADED INTO THE JUNGLE LIKE KING-GODDAMN-KONG.

BOTTOM CAPTION (Jerry): THE BRASS MADE THE MISTAKE OF ACTUALLY BELIEVING THEIR FIELD REPORTS. KHE CHOU WAS SUPPOSED TO BE "PACIFIED"-- LIKE YOU COULD PACIFY ANYTHING IN THIS JUNGLE.

Panel 3: Angle of Jerry whispering to one of his buddies, our buddy Calvin from last page.

CAPTION (Jerry): I HADN'T BEEN IN COUNTRY LONG, BUT I'D PICKED UP A COUPLE OF THINGS ABOUT THE NATIVES. ONE-- THEY NEVER READ FIELD REPORTS.

JERRY: I DON'T LIKE THIS, MAN. HE STANDS OUT LIKE A SEARCHLIGHT.

CALVIN: YEAH, AND IF HE GETS CAPPED, GUESS WHO TAKES THE SHIT?

Panel 4: THE AMERICAN has emerged in a clearing which leads into the village of Khe Chou. It's a typical Vietnam village, if there is such a thing-- thatched roofs on the huts, fairly primitive living conditions, etc. Smoke drifts up through the "chimneys" of a couple of the huts, and we can see some of the villagers outside, milling around the village square. Not too specific in this shot-- we'll get into it later.

CAPTION (Jerry): TWO-- NOTHING WAS EVER CLEAR.

AMERICAN: YO! HELLO!

7

Panel 1: Most of the peasants have run away, but a few of the braver men-- small men by comparison with THE AMERICAN-- hang in there, watching our hero warily-- as if expecting trouble. We can see expectant, frightened faces peeking out from behind the doors of the huts.

 While Jerry sticks relatively close to THE AMERICAN, the rest of the men take up positions around the perimeter, armed and loaded. The men are plainly nervous about this whole situation.

 Note that the camera and sound guy are in the background, continuing to film all this.

CAPTION (Jerry): HE MOVED INTO THE CENTER OF THE VILLAGE LIKE HE WAS SOME KIND OF MOVIE STAR.

AMERICAN: GLAD TO MEET YOU. THERE'S NOTHING TO BE SCARED OF-- WE'RE HERE TO HELP YOU--

BOTTOM CAPTION (Jerry): WHAT THE HELL DID HE EXPECT? WE WERE INVADERS-- THE ENEMY.

Panel 2: We're cutting to an angle of the cameraman, whispering angrily at his sound man. The cameraman is very unhappy.

CAMERAMAN: I'M NOT GETTING SHIT-- WE NEED A GROUP SHOT--

SOUND MAN: THE CIVILIANS DON'T LOOK TOO HAPPY TO SEE US, PHIL--

CAMERAMAN #2: THEY DON'T HAVE TO BE HAPPY-- THEY JUST HAVE TO MAKE THIS SHOT.

Panel 3: The soundman is standing next to the perplexed AMERICAN, trying to reassure him as he (the soundman) prepares to pull some of the natives from one of the huts.

AMERICAN: WHAT'S THE PROBLEM?

SOUNDMAN: IT'S COOL, IT'S COOL-- HOLD YOUR MARK WHILE I ROUND UP A FEW EXTRAS--

Panel 4: An angle from Jerry's position as he glances over in time to see the soundman entering one of the huts. Jerry is stunned by this "bad move", tactically speaking, and he's calling out a warning. The soundman, only half way into the hut, is looking back at Jerry with a casual wave and a smile, a "don't worry" look.

JERRY: HEY-- JESUS, DON'T GO IN THERE, MAN--

SOUNDMAN: WHO MADE YOU DIRECTOR? MIND YOUR OWN--

8

<u>Panel 5</u>: Basically the same angle as panel four, except the soundman's head is EXPLODING from a gunshot from inside the hut.

SOUND EFFECT: PLOOM!

SOUNDMAN: <u>GAA</u>--

9

Panel 1: The soldiers have dropped to their stomachs and opened fire into the offending hut. THE AMERICAN himself has dropped down face first in the dirt, covering his head.
 Jerry's buddy Calvin loses control and starts blasting like a maniac-- the other men are following suit.

CALVIN: OPEN FIRE!

SOUND EFFECTS (gunfire): BRRRRPP! TACKATACKA! BLAM BLAM BLAM!

Panel 2: Very tight shot of Jerry, his eyes squeezed shut under the onslaught, obviously upset at this crazy explosion of violence.

JERRY (shouting): STOP IT! STOP IT, GODDAMN IT!

Panel 3: The fire has stopped. Jerry, with a frantic, frightened expression, is standing with his back flat against the shooter's hut, rifle at ready. Beside him is the open, black doorway looking into the hut.
 THE AMERICAN is on the other side of the door, his face radiating sheer fury. He's ready to just bust inside and kick butt, with no thought toward strategy or safety.
 The soundman's body is still sprawled where it fell.

AMERICAN: --I'M GOING IN--

JERRY: JESUS!

JERRY #2: ALRIGHT, ALRIGHT-- ON MY COUNT-- ONE-- TWO--

Panel 4: THE AMERICAN and Jerry have burst into the hut and found the remnants of a Vietnamese family sprawled inside. The father of the family is lying over an ancient rifle-- the one used to kill the soundman. There's a mother, a daughter, and a young toddler. All have been shot repeatedly during the onslaught.
 Jerry is taken aback by the scene, but THE AMERICAN is still mad.

JERRY: --HE WAS PROTECTING HIS KIDS--

AMERICAN: DIDN'T DO A VERY GOOD JOB, DID HE?

Panel 5: Tight angle of THE AMERICAN's eyes, shadowed in the dappled light filtering in through the hut.

AMERICAN: BURN IT. BURN ALL OF IT.

10

Panel 1: As THE AMERICAN storms away from the hut, Jerry follows, throwing discretion into the wind. He's seen enough for one day.

JERRY: WHAT THE HELL ARE YOU TALKING ABOUT? HE WAS DEFENDING HIMSELF-- CHRIST, YOU WOULD HAVE DONE THE SAME--

JERRY #2: THESE OTHER PEOPLE HAVEN'T DONE ANYTHING!

Panel 2: THE AMERICAN whirls and faces Jerry, grabbing the smaller man by the shirt front. Jerry is startled and his face shows it.

AMERICAN: I'M GONNA TEACH THESE GODDAMN MURDERING SLOPES A LESSON.

AMERICAN #2: WHAT THE HELL ARE YOU? SOME KIND OF COWARD?

Panel 3: THE AMERICAN is torching the flammable fronds of the hut with a zippo lighter while the cameraman takes it all in. Calvin and the other soldiers join in and we can see one or two of them torching other huts in the background. Jerry, still near THE AMERICAN, is stumbling away from the scene in shock, almost as if he were going to throw up.

CAPTION (Jerry): A COWARD? WAS THAT WHAT IT WAS TO FEEL COMPASSION IN THAT WAR? TO FEEL THE PAIN OF ANOTHER MAN'S DEATH?

CAMERAMAN: WE'LL NEVER BE ABLE TO USE THIS, MAN--

AMERICAN: JUST FILM IT. ALL OF IT.

Panel 4: Big panel showing the entire village engulfed in flame. The orange fire is licking around like an inferno, boiling between the huts and buildings. Thick smoke is pouring up, blackening the sky.
 THE AMERICAN stands in the foreground of all this frenzy, practically silhouetted by the flames, exhulting in the heat and destruction. The cameraman kneels in front of him, recording the scene for posterity.

CAPTION (Jerry): WAS THIS WHAT BEING AN AMERICAN WAS ALL ABOUT?

11

Panel 1: We're back in Jerry's dilapidated apartment. On the table in front of him he's got a bottle of Jack Daniel and a 45 caliber revolver. The TV is still on, the light glowing back up into his face.

CAPTION (Jerry): NOBODY SAID A WORD, IT WAS AS IF KHE CHOU HAD NEVER EXISTED. WE WANT BACK INTO THE SHIT. THE AMERICAN WENT BACK TO THE WORLD.

CAPTION #2 (Jerry): HE CALLED ME A COWARD. HE MADE ME LIVE WITH IT.

Panel 2: Another angle of the TV report on the modern day AMERICAN's problems. The AMERICAN sitting in a rigid backed chair, testifying before Congress.

CAPTION (Jerry): AND THEN THE SON OF A BITCH TURNED OUT TO BE A FRAUD-- AN INSTITUTIONALIZED PUT UP JOB.

AMERICAN (On TV): --THEY WANTED THE COUNTRY TO BELIEVE THE AMERICAN WAS SOME KIND OF HERO-- BUT MOST OF THE SQUAD WAS THERE FOR THE MONEY-- THE MERCHANDISING--

AMERICAN #2: -- AND WHEN ONE DIED, THERE WERE A HUNDRED TO TAKE HIS PLACE.

Panel 3: Back to that angle of Jerry looking at his revolver, studying it in the palm of his hand.

CAPTION (Jerry): I'D TURNED ALL THE PAIN INWARD. ALL THESE YEARS-- CHRIST, I THOUGHT I'D DONE SOMETHING WRONG.

CAPTION #2 (Jerry): MY MISTAKE WAS BELIEVING.

Panel 4: We're behind the television as Jerry turns the pistol and FIRES it through the screen. The TV is exploding, sparks and glass flying backward from the impact of the shell.

CAPTION (Jerry): I WAS THROUGH MAKING MISTAKES.

JERRY (cold, deliberate): FUCK YOU.

SOUND EFFECT (gun): PLOOM!

SOUND EFFECT (TV exploding): KSSSSH!

12

Panel 5: We're outside-- a cold, rainy day in New York. Jerry, wearing a heavy overcoat to protect himself from the chill, is tossing the revolver off a bridge into the river below. (Jerry's in the background, throwing the gun toward us, so we can see it.)

CAPTION (Jerry): IT WAS COLD AND WET OUTSIDE. YOU COULD BARELY SEE THE SUN THROUGH THE OVERCAST SKY.

BOTTOM CAPTION (Jerry): FOR SOME REASON, I DIDN'T MIND.

Shut up and tell me a good story!

That's kinda the first rule of writing comics - you gotta leave room for all of the art, while still making the story and dialogue compelling. And I'll tell you, it's not easy to be both brief and resonant!

Of course, that hasn't stopped me from trying. And sometimes, you find yourself with an opportunity to write a story - for some reason or another - that has to be 4-6 pages. This is particularly challenging with comics, because it means that there is even less room for exposition and dialogue than normal. And, because comics are a visual medium, we have to be very thoughtful about which words actually appear on the page. Otherwise, we'll drown out the art!

For this particular story, "Jerrold's Lament", I wanted to explore reasons why someone would consider suicide. So, I did some research on it, and I found that some people view suicide as the only way to take control of what they feel is a chaotic existence. As I read that, I thought a lot about how things like guilt and perception work, and how we're all so often overwhelmed by details of our lives that are relatively temporary.

It made me want to explore what all of that might look like to characters who are not human, and who don't see things as we do. So, I decided to use established characters from my graphic novel, "The Burning Metronome" - a book about otherworldly creatures who've found themselves trapped in human bodies, in our world, trying to make sense of it all.

And of course, suicide is a big topic to deal with. So, I can't say that it made a lot of sense to try to tackle it in 6 comic pages - but I sure did try!

TI always put reference photographs into my scripts, to help the artists (in this case, the brilliant Jolyon Yates and colorist Matt Strackbein) understand what I see in my mind's eye. For this script, they included such things as a picture of an opulent house (because that setting was important for one of the characters), and a photo of someone in despair (we had to leave them out of this book due to copyright issues.)

If you want to compare this script to the finished story, you can find the results at ralanwrites. com/jerrolds-lament online.

If you're looking to write your own comics script, here are 4 tips from me:

1. Remember that only one action per character can happen in a single panel.
2. Think of the panels as photographs - what would be the most important visual to help tell this part of the story?
3. For American print comics, try putting all of your major reveals on even-numbered pages, so that the reader has to turn the page to see it.
4. Comic scripts don't have a specific format in the way that movie scripts do, but there are some typical items that you'll likely see repeated in all of the scripts in this book.

Hopefully, that's all helpful!

Cheers.

– R. Alan Brooks
November, 2021

PAGE 1- 3-4 panels. This is the dynamic action/hook page, so do what you think works best here to set the story off on a highly dramatic tone.

PANEL 1:

EXT. BRIDGE- DUSK

It's a foggy evening, just before nightfall. The bridge is deserted; we get the sense that this is a small town, no cars, no people. The bridge should be much higher up from the water/ground than the ref photo.

PANEL 2:

Zoom in on a teenage boy standing on the edge, ready to jump. We need to feel the danger and sadness of this moment.

PANEL 3:

The kid jumps.

PANEL 4:

Magical flash.

PAGE 2- Six panels

PANEL 1:
INT. DANIA'S HOUSE- DAY
The kid finds himself in a chair, in an opulent old house. Our magic effect is smoking off of him.

This house is almost its own character in the book, so how you design it is important.

The angles that the house is shown from should make it very intimidating.

PANEL 2:
The kid looks around, surprised.

PANEL 3:
Zoom out to see that he's sitting across from Walter, who is also seated, with Dania standing in the background. Her body language suggests that she is unhappy and impatient. Walter looks compassionate and calm.

WALTER
This is not what we usually do.

PANEL 4:
Walter leans forward.

WALTER
Dania is...impatient. So, I need to be direct.

KID
Who are you?

KID
Did I *die?!*

PANEL 5:
Walter speaks, with Dania in the background. Dania is annoyed, so her body language is turned away from Walter.

WALTER
Something I've observed about human beings: you excel at creating conflict with each other.

WALTER
Especially over immaterial differences.

WALTER
Hair color, eye color, height...

DANIA
Skin color.

PANEL 6:
Walter continues, now thinking out loud to himself more than talking to the kid. Dania looks more annoyed.

WALTER
Skin color.

WALTER
It's all so subjective; it's hard to remember.

WALTER
You even have wars over differences in the grunts and noises you make.

WALTER (smaller font)
Language is such an arbitrary thing to fight over.

DANIA
They're *all* arbitrary!

PAGE 3 - Eight panels

PANEL 1:
Walter turns his attention back to the kid, who still looks freaked out.

WALTER
You probably get that Dania and I have an...outsider's perspective on humanity.

KID (smaller font)
I-I don't know what that means.

WALTER
I'm going to ask you not to dwell too heavily on that for now. But she and I often have reason to intervene in human conflicts.

KID
So you're, like...angels?

PANEL 2:
Walter, eyes full of compassion. Shot is perhaps over kid's shoulder?

WALTER
We are anything, but divine. But *you*--

WALTER
...I want to say--

WALTER
I hope, at the end of this conversation--

PANEL 3:
The kid's face shows despair.

WALTER (off-panel)
--you make a different choice than you just did.

PANEL 4:
Dania scowling.

WALTER (off-panel)
But more directly, this situation is about *my* bad decisions. I need to show Dania that there's hope for your kind.

PANEL 5:
The kid, still depressed, but also confused. Walter looking more serious.

KID (smaller font)
Hope?

KID (smaller font)
I just tried to...

WALTER
We are inundated with remorseless humans. You obviously feel shame for something.

PANEL 6:
Walter leaning forward again, making his point very gravely.

WALTER
So, I need to ask:

WALTER
What have you done...that is so atrocious--

WALTER
--that you need to murder yourself to atone?

PANEL 7:
Kid, surprised.

KID (smaller font)
Atrocious?

KID
No, *I* didn't do anything...

PANEL 8:
Walter looks back at Dania. They are both confused.

PAGE 4- Eight panels

PANEL 1:
Walter's face: confusion; searching for the appropriate response.

WALTER
I...I'm confused then.

WALTER
I wanted to show Dania that there *are* human beings who take responsibility for their misdeeds.

PANEL 2:
The kid is angry now.

KID
I didn't *do* any misdeeds!

PANEL 3:
Walter and Dania, who look sincerely perplexed.

WALTER
You wanted to end your life for...*nothing?*

DANIA
Why'd you jump?

PANEL 4:
On kid, looking hopeless.

KID
Not *nothing*.

KID
I just...everything's wrong. I mean like, the government...the *environment*--something's gonna kill us all, and I can't even get things right in my own life.

KID (smaller font)

I don't know why I'm *bothering*...

PANEL 5:
Walter again looking compassionate, Dania unsure in the background, kid in panel.

WALTER
We want to understand.

KID
I didn't ask to be born. I had no control over that. If I'm gonna die eventually, anyway...

WALTER
You want to control when.

KID (smaller font)
Yeah, I guess.

PANEL 6:
Walter, looking sweetly concerned.

WALTER
Alright...what is your name?

KID
Jerrold.

WALTER
I'm Walter.

PANEL 7:
Walter sits back in his chair again, deep in thought. The kid looks sad. Dania looks concerned for the first time.

WALTER
I don't think this is the conversation that either Dania or I expected.

KID

Sorry to disappoint.

DANIA
You didn't disappoint us.

PANEL 8:
Walter looks back at Dania, who returns his look as if they've finally connected over something.

WALTER
No. You...you've given us a lot to think about. How little we understand about you.

PAGE 5 - Six panels

PANEL 1:
Walter reaches into his pocket.

WALTER
I'm going to show you something. Then Dania is going to put you back on that bridge.

PANEL 2:
We see a monocle in his hand, and the kid's hand reaching out for it. The monocle should be ornate, as if it belonged to an ancient culture of some kind.

WALTER
As I said, I hope you make a different decision. It's clear that you're in pain...and I don't know much about removing it.

PANEL 3:
The kid puts the monocle to his eye.

WALTER (off-panel)
All I can say is--no matter how much your world feels like it's choking you--

PANEL 4:
This is the reveal of Walter and Dania's true forms, as seen through the monocle. We have to make it clear that this is the view through the monocle. Maybe we see their human forms on the edges of the panel, outside the monocle? Even in monster form, Dania's body language is confrontational; turned away, arms folded.

WALTER
--there's so much more for you to discover.

DANIA (smaller font)
That'd be true even if you didn't *show* him, Walter.

PANEL 5:

Human-Walter pulling the astonished kid's hand down, so he's not looking through the monocle anymore.

WALTER
She's right.

PANEL 6:
Walter, waving goodbye through another magic flash.

WALTER
Goodbye, Jerrold.

PAGE 6 - Five panels

PANEL 1:
EXT. BRIDGE- DUSK
Kid on the bridge again, about to jump, our magic effect subtly smoking off of him.

PANEL 2:
He reconsiders.

PANEL 3:
He climbs back over to safety.

PANEL 4:
He walks away, into the fog, on his phone.

KID
Yeah, this is the suicide hotline?

END

Bryan Talbot has been creating acclaimed graphic novels for decades. His works span from the sensitive portrayal of having survived an abusive childhood in **The Tale of One Bad Rat** to the universe-hopping science fiction of **The Adventures of Luther Arkwright** to the anthromorphic steampunk of the **Grandville** series. Along the way, he has won awards and recognition not only from within the comics community, but from the worlds of science fiction and of mainstream literature as well, including having been chosen as a Fellow in the Royal Society of Literature.

While Talbot has not written quite all of his most famous works (the award-winning graphic novel **Dotter of Her Father's Eyes** was written by his wife, Mary), he has drawn them all himself. But here he shows us the script for a somewhat less-known work, the comical adventure **Cherubs!**, for which he provided the script but relied on Mark Stafford for the final art. As such, this shows us how Talbot works when he's communicating to another artists, including where he feels the need to be detailed in his vision and where he trusts the creativity of his collaborator to fill in the holes and bring the work to life.

Cherubs! was sectioned not into "chapters," but into "cantica" which were subsectioned into "canto." What is presented here is the script for the first cantica.

– Nat Gertler

CHERUBS!
PARADISE LOST
CANTICA ONE

Number 1 of 4

Page 1

Splash page: Long shot: Heaven.

The sun shines brightly over pile upon pile of fluffy white cloud that disappears into the distance. A central mountain of cloud holds occasional buildings and piazzas in white stone and marble - all classical Greek pillars and domes - leading up to a whole celestial city at the far top. A tall wall of white stone, like the curtain wall of a castle, runs along the lower reaches. Angels and cherubs flit about (none outside the confines of the wall). A Cherub (Joe) zooms past us carrying a white plastic bag.

Text:

CANTO ONE
MURDER IN HEAVEN

CREDITS:

Script and layouts:

Bryan Talbot

Art:

Mark Stafford

Lettering:

?

Page 2

1. Down near the lower reaches, passing angels with harps, drifting wingless souls in white togas and occasional flitting cherubs, we focus on Joe as he zooms towards us. A couple of angels regard his zooming around with distaste. Perhaps he's startled one.

2. He heads down to a cloudbank where the others are hanging out. Enoch is sitting to one side, studying a chessboard. Mal has a catcher's mitt and is half-heartedly tossing a ball in the air and catching it. Jasper has one of those table-tennis bats with the ball attached by elastic and, as they talk, remembers to hit it now and again. Zak, the youngest-looking, constantly flits around. In the cloud valley behind them, other cherubs are playing softball or lounging about watching the game.

Joe:

HI GUYS.

Zak:

HI JOE!

Enoch:

HELLO JOSEPH.

Jasper:

HEY, DUDE! HOW'S IT HANGIN'?

Page 3

1. Joe starts throwing them pieces of white cake from the bag, which Mal and Jasper catch and munch.

Joe:

HOW'S IT HANGIN'? YOU CAN **SEE** HOW IT'S HANGIN', JASPER! JEEZ, WHAT A DOPE.

HERE. PICKED UP SOME ANGELCAKE.

Mal:

COOL.

2. Focus on the chessboard and Enoch as he studies it, his hand reaching to move a piece. the white pieces are angels and cherubs (as pawns) and the black ones are devils and imps.

Enoch:

NO THANKS.

3. CU: Chessboard. Enoch's hand moves a piece.

Enoch (From Off) :

HMM. **CHECK.**

4.

Joe:

 PLAYIN' WITH YOURSELF AGAIN, ENOCH?

Enoch:

 MY DEAR JOSEPH, IF I DIDN'T CONSTANTLY
ENGAGE MY MENTAL FACULTIES I'D EITHER GO **COMPLETELY
INSANE** OR DIE OF **BOREDOM.**

Jasp:

BUT THIS IS **HEAVEN**, ENOCH. **NOBODY** DIES IN HEAVEN.

5. He returns his attention back to the board

Enoch

I WAS SPEAKING **METAPHORICALLY** YOU MORON.
AH, WHAT'S THE USE?

6.

Joe:

ENOCH'S GOT A POINT THOUGH. I'M **BORED** OUTTA MY SKULL.

Zak zips up alongside him holding up his baseball bat.

Zak

WE *COULD* PLAY BALL.

Page 4

1. Longshot, looking up at their cloud from the cherubs playing ball in the valley below. As they talk we cut in close as one tears round to score a home run. Nobody cheers or gets excited. In fact one up close yawns widely.

Joe

JEEZ, ZAK. NOT **AGAIN**. AFTER YOU'VE SCORED YOUR TRILLION ZILLIONTH **HOME RUN**, WHO GIVES A SHIT?

IT'S JUST **TOO** PERFECT HERE.

2. Jasp

YEAH! THERE'S NOTHIN' **EXCITIN'**! NO **SEX**, NO **WAR**, NO **CRIME**, NO **VIOLENCE**, NO **SEX**...

Mal

Y-YOU MEAN LIKE ON **EARTH?** NOW THAT'S A **HAPPENIN' PLACE**, DUDE!

3. CU of Joe & Zak over a flashback: a Renaissance Italian studio, our boys hanging in the air, posing for painters and sculptors who are busily embellishing their works with cherubs. Fun – lots of smiling and laughing. Lots of nice period detail – it should be rich and sensual - a vivid visual contrast to the simple white clouds of heaven. A pulchritudinous semi clothed model or two also posing for the same (or another) painting. Perhaps one getting changed in

the BG. Extravagant drapery, grapes, wine bottles, etc.

Joe:

BUT WE **NEVER** GET SENT THERE ANYMORE!

LAST TIME WAS DURIN' THE **RENAISSANCE,**
Y'KNOW, POSIN' FOR THOSE **ITALIAN GUYS**...

Zak

THEY WERE COOL.

4. CU Jasper over Renaissance Italy. He's pouring red wine in a stream from a
basket bottle through the air and into his mouth.

Jasp

 YEAH, COOL. AND WHAT WAS THAT **STUFF? VINO!** YEAH, I LIKED
THAT. **VINO**. COOL.

5. Back in Heaven. Mal screws up his face. Jasp makes to stick 2 fingers down
his own throat.

Mal;

 MADE ME **PUKE**.

Jasp

 AT LEAST IT WAS **DIFFERENT!** YOU JUST **CAN'T** PUKE HERE. **SEE**
-

Page 5

1. CU: sticking his fingers down his throat and retching violently at the
 reader

Jasp:

BLEAH! BLEAH!

...NOTHIN'!

2. Mal upset at Enoch's reaction.

Mal:

AND ON EARTH, THEY HAVE **FASHIONS!**

Enoch:

YES, WE'VE NOTICED YOUR **HAIRCUT**, THANK YOU.

LOOKS **LUDICROUS.**

Mal:

BUT IT'S THE **LATEST STYLE** DOWN THERE!

 2. CU Joe.

Joe:

 I JUST WISH **SOMETHIN'** WOULD HAPPEN...

Mal (from off-panel):

 HEY!

 3. Joe snaps round (thinking it's something interesting). Mal cross and
 puzzled.

Joe

 WHAT?

Mal:

 IF THERE'S NO **CALORIES** IN HEAVEN, HOW COME I'M **FAT?**

Zak:

CHECK IT OUT! IT'S **THE OLD MAN!**

4. A glowing meteor-like object is in the sky, leaves a long white vapour trail. it zig zags erratically, zooming across the sky before disappearing into the upper levels of Heaven.

FX;

EEURRRRRMMMMM!!

Zak

WOW! HE SURE MOVES IN **MYSTERIOUS WAYS!**

5.

Mal

 HEY, WHAT SAY WE GO SPY ON THE
CHICKS' **CHANGING ROOMS?**

Joe

GHAWD, MAL. WE DO **THAT** EVERY DAY!

6. Mal points at Joe.

Jasp:

 THERE **AIN'T** NO DAYS HERE. I MEAN, THERE
AIN'T NO NIGHTS - IT'S **ALL THE SAME.**

Mal:

YOU GOT A **BETTER** IDEA?

Page 6

1. A flock of doves rises, disturbed by the Archangel Abaddon as he walks along a massive marble columned terrace with a view across the endless vista of Heavenly clouds.

2. Back view as he reaches the columns and looks down. Small figures of human spirits and angels move far below.

3. CU: He gazes down: serious, intellectual. Just hint at contempt. Perhaps one eyebrow raised.

4. Same POV – zoom out. With beating wings, two angels land vertically behind him. He appears not to notice.

5. They stand behind him, respectful. One holds out a rolled parchment. Abaddon doesn't turn around, just raises his eyes skyward in boredom and holds out his hand for the scroll.

Abaddon

SPEAK.

Angel:

A-A **MEMO**, ARCHANGEL.

Page 7

1. Ab reads the scroll as the angels in the BG glance at each other nervously.

Abaddon:

YET ANOTHER **EDICT** HANDED DOWN FROM **ABOVE?**

2. Still reading, he dismissed them with an imperious wave of his hand.

Abaddon:

YES, YES.

DISMISSED.

Angels:

MILORD!

3.AB is tearing the parchment in half. In the BG we can see the angels flying away.

FX:

RIP!

4. CU: He closes his eyes, looking immensely sad.

5. CU, same POV: His eyes flick open, staring at us with a determined and evil glint.

FX (Running across pans 4 & 5):

RIP! RIP! RIP! RIP! RIP! RIP! RIP! RIP!

6. He tosses the shreds of parchment into the air.

Abaddon:

BETTER TO **RULE** IN **HELL** THAN **SERVE** IN **HEAVEN.**

7. CU: He takes a pure white mobile phone from his robe.

8. He's flipped it open and is punching up a number.

FX:

BEEP BE-BEEP BEEP BEEP!

9. CU: ABADDON speaking into the phone, a slight sneer playing around his mouth.

HELLO LUCY.

Page 8

The Throne room of Hell: A huge cavern decorated by H.R.Giger, Bosch, Breugal and Gustave Doré: Roaring fire, long black shadows, churning smoke.

Compared to the static quality, tranquillity and simpicity of Heaven, this is really lurid and visually shocking. Lots of dramatic underlighting and black shadow.

We should see at least some souls being tortured, boiled in a pot, whatever, even if it's just in the distance – perhaps through a window in the cavern looking down on the vast cavern beyond with its firepits and demons working with pitchforks.

Lucifer sits on his throne, its wicked spikes impaling skulls and half-rotten heads. Snotgobbler and Fartsucker crouch subserviently in attendance, one holding a jug and goblet on a tray. His phone is shaped like a great curving goat horn.

The Crown of Hell should be visible somewhere (it only comes into the story in about 12 issues time, but let's get it in here) – perhaps hanging on one of the throne spikes.

Lucifer:

ABADDON? I'VE TOLD YOU: **DON'T**
CALL ME **LUCY!**

2. CU: Abaddon:

Abaddon

YOUR **OFFER.**

I **ACCEPT.**

3. Hell. CU Lucy:

Lucifer :

WICKED!

BUT DON'T FORGET! I NEED **PROOF** THAT YOU'RE COMMITTED. SOMETHING **TRULY EVIL**. IT'S PART OF THE **JOB.**

4. Heaven. AB snaps the phone shut.

Abaddon

I WON'T FORGET.

Lucifer (from Phone):

SOMETHING THAT WILL...

FX:

SNAP!

Page 9

1. Back in Hell.

Lucifer:

OHHH! DON'T YOU JUST **HATE** IT WHEN THEY DO **THAT?**

2. A smile is creeping over his face.

Lucy:

HMMM!

HA!

HA HA!

3. He's rocking back with laughter, long sharp teeth bared. If we see his tongue, it's forked.

FX all around him (like the Joker):

HA HA HA HA HA HA HA HA HA HA HA

4. He's risen to his feet, so for the first time we can see his goat's legs. We look up at him, past terrified Snotgobbler, at this barrel chested, muscular creature, its head rolling back in laughter, its fists clenched. Dramatically uplit.

Snotgob

W-WHAT IS IT, MASTER?

Lucy (Lettering getting larger and bolder):

FREEDOM, SNOTGOBBLER, **FREEDOM!**

AFTER **ALL THIS TIME!**

 4. Zoom in to CU of Lucy's evil face.

Lucy:

I'LL WALK THE EARTH ONCE MORE!

Page 10

 1. Back in Heaven. We're looking through binoculars across an ornamental lake in the clouds. Women and girls are swimming and diving. There are bulrushes, swans and flamingos and a domed Greek summerhouse. We pan to a roofless white stone edifice where the women are changing out of their togas to bathe.

(Balloon from off):

YO. CHECK OUT THE ONE WITH THE **BIG BAZONKAS.**

2. Switch direction. The Cherubs are all looking down at us from behind a cloud, each one with a pair of pure white binoculars apart from Jasper, who has a ludicrously huge white telescope. Behind them, the cloudbank rises sharply to an imposing pillared acropolis - the chamber of the Grand Council.

JASPER

OH, SHE'S **ON FIRE**, MAN, SHE'S **ON FIRE!**

Joe lowers his binocs and looks at him.

Joe:

WHADDA **YOU** KNOW? YOU'RE A **PERPETUAL INFANT!**

3. Jasper:

WELL, YOU KNOW WHAT I MEAN...

Mal:

YOU GUYS EVER SEE ANY **GIRL** CHERUBS?

4. All:

UH HUH.

Zak:

LOOK, DUDES! IT'S **ABADDON!**

5. Abaddon walks past us, heading upwards past the Cherubs in the BG who turn to look up at him. He's not seen them.

Enoch

WHAT'S HE DOING **THIS** FAR DOWN? HE'S AN **ARCHANGEL,** FOR GOD'S SAKE.

Joe:

WHO **CARES?** PROBABLY RUNNIN' SOME **ERRAND** FOR THE **OLD MAN.** SEE - HE'S GOIN' TO THE **GRAND COUNCIL.**

Mal:

BUT...WHAT'S **THAT** HE'S CARRYIN'?

Page 11

1. CU: the pure white old-fashioned tommy gun he's carrying.

2.

Jasper

LOOKS LIKE A...WHADDYACALLIT... **CROSSBOW**...WITHOUT, Y'KNOW, THAT **THING** THAT GOES ACROSS.

Enoch:

THAT'S A **GUN**, JASPER.

3.

Jasper:

COOL.

Enoch and Joe exchange concerned glances.

Joe:

HEY, WHAT'S **GOIN' ON?**

4. Inside the Council Chamber, a dozen old angels are sitting around on benches that are part of a stepped circular debating area - a bit like a lecture theater. One is on his feet, droning on. The chamber is surrounded by a corridor of pillars.

Speaker:

...AND FURTHERMORE...**NEVER**...IN MY HUMBLE OPINION...SHOULD WE HAVE STOOD...ON THE HEAD OF THAT BLOODY **PIN** IN THE FIRST PLACE.

WHENEVER...

Page 12

1, Behind the columns surrounding the chamber the Cherubs approach cautiously, hanging in the air, their wings vibrating like those of hummingbirds.

Zak:

WHERE'S HE **GONE?**

Jasper

WE AIN'T **ALLOWED** IN HERE, JOE.

Mal:

WE'RE GONNA GET IN **TROUBLE**, MAN, WE'RE GONNA GET IN **TROUBLE.**

Joe:

SHUT IT, YOU BIG **WUSS.**

Enoch (Small lettering):

CAN'T YOU NUMBSKULLS BE **QUIET?**

2. In the Chamber, the speaker is interrupted by the sight of Abaddon stepping out from behind one of the pillars brandishing the machine gun. The council & the Speaker gape in astonishment.

Speaker:

…AND, MOREOVER…

Abb:

SILENCE!

Speaker:

EH?

HOW **DARE…**

3.

He blasts away with the tommy gun

Abaddon:

I BRING A **MESSAGE** FROM **LUCIFER!**

FX

BUDDABUDDABUDDABUDDA

4. The cupids, wide eyed with shock.

 5.Long shot of the chamber. Abaddon alone stands, holding his smoking machine gun, surrounded by the bodies of the council.

Page 13

 1. CU: Jasper, shouts incredulously.

 Jasp:

HO - LEE SHEE - IT!

 2. Too late, the Cherubs all clap their hands over his mouth.

3. AB's shadow falls over them as they quake with fear. Zak and Japer hugging each other.

 4.CU: Abby, amused.

 Abaddon:

 OH. I WAS **OBSERVED.**

 WELL, SAY **HELLO...**

5..He levels the smoking gun at us, now totally grim.

Abaddon

...TO OBLIVION.

6. We look along the gun towards the Cherubs terrified faces.

Page 14

TITLE:

CANTO II
ESCAPE FROM PARADISE

1. Switch angle, so we're looking back at Ab past the Cherubs. Joe points at him.

Enoch:

YOU **WON'T** GET AWAY WITH THIS, YOU KNOW.

Joe:

YEAH! YOU'VE KILLED THE **GRAND COUNCIL!** YOU'RE GONNA **BURN!**

2. Abaddon points the still smoking gun upwards, away from them.

Abaddon:

CONGRATULATIONS. YOU'RE IN **LUCK.**

I NEED **WITNESSES.**

SPREAD IT AROUND. TELL **EVERYONE** WHAT YOU SAW.

I'VE COMMITTED THE **FIRST** MURDER IN **HEAVEN.** A DEED SO **VILE, LUCIFER** WILL BE **WELL PLEASED.**

3. He turns to leave, tossing aside the gun.

Cherubs:

L-L-LUCIFER?

Abaddon:

SILENCE, YOU **CELESTIAL ANKLEBITERS!**

I GO TO FULFIL MY **DESTINY.**

4. As he walks away, he fades away, becoming transparent.

(+ music notes) "Start spreading the news...

I'm leaving today...

I'm gonna be a part of it..."

5.

The Cherubs are shocked.

Zak:

HE'S **GONE.**

Mal:

WOW, MAN. THAT WAS **HEAVY**, DUDES.

Enoch:

THAT **SONG...**

...I **RECOGNISE** IT...

Behind him, Jasper is picking up the machine gun.

Jasper:

 CHECK IT OUT, DUDES. HE LEFT **THIS...**

Joe :

JASPER! NO! PUT IT...

Page 15

1.Suddenly a spotlight beam frames them, Jasper at the front pointing the gun -
an ludicrously incriminating position.

Jagged balloon from off:

DROP THE WEAPON!

Balloon from above:

 2. We look down from high above: two or three angels hover, their beating wings reminiscent of helicopter blades. Past them we can see the cherubs in the spotlight.

 Angel (through white megaphone):

AND STAY RIGHT WHERE YOU ARE!

FX:

FLAP FLAP FLAP FLAP FLAP FLAP FLAP FLAP

 3. The Cherubs exchange shocked glances,

Enoch:

Oh my God!

Joe:

 Wing it!

4. They scatter.

FX:

WHOOSH!

5. The Cherubs are hiding behind a cloudbank, panting. Mal is peeking back over the cloud.

Mal:

I **THINK** WE LOST THEM.

Zak:

W-WHAT ARE WE GONNA **DO?** THEY THINK IT WAS **US!**

Jasper:

WE GOTTA TELL 'EM WHAT **HAPPENED!**

Joe:

OH **YEAH?** AN' **WHO'S** GONNA BELIEVE **US?**

Page 16

1.

Joe:

LISTEN. WHAT IF WE BROUGHT HIM **BACK?** MADE HIM **TALK?**

Mal:

ARE YOU **CRAZY?** HE'S A FRIGGIN' **ARCHANGEL!**

2. CU: Enoch:

BUT THERE'S **FIVE** OF US. WE COULD **TRY.** I DON'T RELISH SPENDING THE REST OF **ETERNITY** AS THE **DEVIL'S SPITTOON.**

3

Zak:

BUT **WHERE'S** HE GONE? HE COULD BE **ANYWHERE!**

Enoch;

NOT **ANYWHERE** ZACHARIAH. **NEW YORK. THAT** WAS THE SONG HE WAS SINGING -**"NEW YORK, NEW YORK."**

 IT'S ON **EARTH.**

4

Mal:

COOL.

5. We're looking down on them as Joe and Mal dig a hole in the cloud with white spades, the other three look on. The hole's about ten foot deep with a mound of dug cloud to one side.

Joe:

 S'NO USE MAN. **SOLID CLOUD.**

Zak:

IF ONLY WE COULD JUST **FADE AWAY**, LIKE ABADDON.

Enoch:

ONLY HIGHER FORMS CAN **TRANSMIGRATE.**

Mal:

THERE'S **NO** WAY OUT.

Jasper:

 AN' ONLY **ONE** WAY IN.

6.

Joe:

JASPER! YOU'RE A **GENIUS!**

Jasp:

I **AM?**

I MEAN, **I AM.**

WHY?

Joe:

QUICK, GRAB SOME OF THIS **CLOUD.**

Page 17

1. We look along a staircase that spirals up through starry space and leads to the ornate Pearly Gates, the only break in the high white wall surrounding Heaven. The stairs are crowded with souls, constantly murmuring.

Voice from stairs;

 HEY, QUIT **PUSHIN'**!

2.CU: Saint Peter's hand strikes an old-fashioned desk bell.

 FX:

 PING!

Balloon from off:

NEXT.

3. He's sitting at a big old desk in front of a computer screen. There's a brass button on his side of the desk. He looks like George Bernard Shaw and sounds like Basil Fawlty. Like Fawlty, he's boiling with disdain and impatience.

Beside the gates, the entrance area is composed entirely of cloud except for a long, sweeping, pillared staircase at the other side of St. Peter's desk that ascends upwards into the clouds.

There's a notice by the gate that says "Wait here" and a multitude visible beyond.

An overweight guy in a grimy suit comes forward.

St. Pete:

 YES? YES? COME ON! **NAME?**

Guy:

HAROLD GREENBAUM.

4. St. Pete looks at the screen of the white computer and taps while dipping a white doughnut into a mug on the desk. Can we see the Cherubs sneaking by in the BG?

St Pete:

WELL, EVERYTHING SEEMS TO BE IN ORDER. BUT HOW DID YOU DIE?

5. The guy mimes throwing a fridge, holding it above his head.

 Greenbaum:

WELL, I KNOW THE WIFE'S **PLAYIN' AROUND**. SO I COMES HOME EARLY - AN THERE SHE IS IN **BED!** AND **THERE'S** HER BOYFRIEND, BUTT NAKED, ON THE **BALCONY** BELOW! SO I PICKS UP THE **REFRIGERATOR** AND THROWS IT AT 'IM!

AN' GUESS **WHAT?** I HAVE A LOUSY **HEART ATTACK!**

6. CU; Pete's pressing the button on the side of his desk.

St. Pete:

HUMM. **FAIL!**

FX:

CLICK!

7. Harold disappears down a trapdoor with an echoing scream and a hint of hellfire.

FX:

WHOOSH !

Harold:

YAAAAAH!

PING!

St. Pete (from off):

NEXT.

Page 18

1. We're looking from the cloudbank behind St Peter, past where the cherubs are hiding. A couple of them are sneaking over to the Pearly Gates, holding up chunks of cloud as camouflage.

Before St Pete, another guy comes forward. He's naked and hiding his crotch with his hands.

2nd Guy:

ER,…MARVIN KOMINSKY.

St. Pete:

YES, YES, AND **HOW** DID YOU **DIE?**

 2. Marvin explains, one of his hands waving in the general direction of an imaginary falling fridge.

Marvin:

WELL, SIR, I HAPPEN TO BE A **NUDIST,** AND I WAS JUST SUNBATHING ON MY **BALCONY** WHEN **WHAAP!** THIS **REFRIGERATOR** LANDS RIGHT ON TOP ON ME! I **COULDN'T** BELIEVE IT!

 3. St Pete types it up and waves him through. In the BG we can see the Cherubs moving past him towards the gates.

St. Pete (typing):

I SEE…**AC-CID-EN-TAL DEATH.** ENTER!

WELL, GO ON, GO ON! I **HAVEN'T** GOT ALL **ETERNITY!**

4. He pauses on his way to the stairs, looking around. Pete in the FG, rolls his eyes and strikes the bell.

Marvin:

OH, ER, THANKS.

BUT…ER, WHERE'S THAT **SINGING** COMING FROM? I CAN'T **SEE** ANYBODY.

St. Pete

 JUST THE **CHOIR INVISIBLE**. NEXT!

FX:

PING!

5. A third guy staggers in nervously and walks towards St P in the BG. He too is naked. In the FG, The last of the cherubs sneaks past us, through the gates.

3rd guy:

ER, LARRY SMITH YOUR HONOUR.

St Pete:

YES?

6. Front-on Larry.

Larry :

WELL, SIR, IT'S LIKE…I WAS SITTIN' IN THIS **REFRIGERATOR**, MINDIN' MY OWN BUSINESS…

Page19

1. Outside the Wall of Heaven, by the gates, the 5 have regrouped. They're standing on a narrow ledge of cloud with their backs to the wall. Behind is the staircase full of queuing souls and beyond that just cold starry space.

Mal:

 L-LOOKS A LONG WAY DOWN.

Joe:

WE GOT **WINGS**, AIN'T WE?

 READY? ONE, TWO, THREE, **JUMP!**

2. They all leap off, dropping like stones.

All:

AAAAAAAAAAAAAAAAAAAAAAAAAAA

3. They hurtle past, through space.

AAAAAAAAAAAAAAAAAAAAAAAA

4.. They stop screaming and look at each other, blinking. Just below is a soggy grey cloudbank.

Zak:

 AAAAA…UH?

HEY! HOW **LONG** WILL THIS TAKE?

Enoch:

 GOD KNOWS.

Joe:

JUST **THINK!** WE'RE GOIN' TO **EARTH!**

 NEW YORK, HERE WE...

5. They disappear into a huge soggy cloudbank, leaving ripples as they enter.

FX:

SPLOOOSH!

Page 20

1, Inside: A solid grey mist. Silence. Zak emerges. He's in gray monochrome.

Zak:

HEY? JOE? ENOCH? MAL? JASPER?

YOU GUYS **THERE?**

2. Jasper & Enoch drift up.

Jasper:

JEEZ! IT'S **CHILLY** HERE!

Enoch:

AND **DAMP.**

3. Mal & Joe arrive.

Mal:

AN' WHAT'S THAT **SMELL?**

Joe:

NOTHIN'. IT SMELLS OF **NOTHIN'.**

4.

Jasper:

YEAH! IN HEAVEN IT WAS ALL, SORT OF...**PERFUMED.**

Enoch:

YOU REALISE **WHERE** WE ARE. DON'T YOU?

Joe:

YOU MEAN...

5.

Enoch;

WE'RE IN **PURGATORY!**

WE'RE TRAPPED IN **LIMBO!**

All;

AAAAAAARGH!

Text:

TO BE CONTINUED...

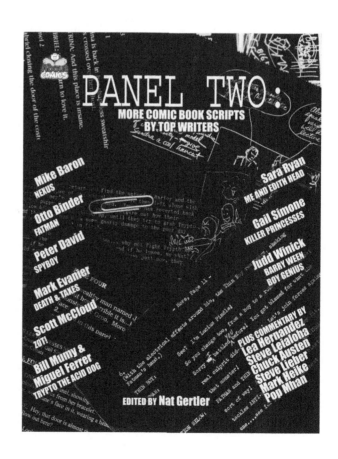

Where inspiration and spontaneity prime a comic's pump, create a vision, propel it forward, and give it life, **Comics Creator Prep** raises the level of comics craft to give a creator the requisite tools to consistently realize that vision. It shows creators how to use the tools in their comic toolboxes well.

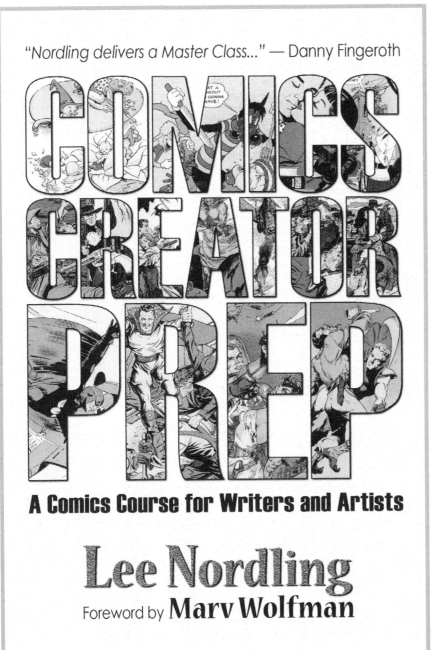

"Nordling delivers a Master Class..." — Danny Fingeroth

COMICS CREATOR PREP

A Comics Course for Writers and Artists

Lee Nordling

Foreword by **Marv Wolfman**

"If you've ever wished you had someone to walk you through the potential pinnacles and pitfalls of a career in comics, then Lee Nordling's **Comics Creator Prep** is the book for you. In this guide to a plethora of perplexing situations you're likely to find yourself in at one point or another in the world of sequential art, Nordling delivers a Master Class in the creative and business issues that confront pretty much everyone who's ever tried to tell a story in words and pictures. Lee will help you avoid many common mistakes comics beginners—and grizzled pros, for that matter—often make. And for those times when you do find yourself in the middle of a thorny situation, his insights and advice should enable you to dig your way out faster and more gracefully than you otherwise would have." —**Danny Fingeroth**, comics writer, editor and historian; author of books including **Superman on the Couch: What Superheroes Really Tell Us About Ourselves and Our Society**

"There's no one magic way to create comics, but Lee Nordling brings a lifetime of experience in strips, periodicals and books to a discussion of how to approach the medium as a professional and do your best work." —**Paul Levitz**, comic book writer, educator, past President and Publisher at DC Comics

"I really wish I had been able to read Lee Nordling's Comics Creator Prep forty years ago when I was a newbie at this comics lark. It's stuffed full of invaluable information and useful advice about the craft of storytelling and using the medium to its full potential. It covers everything from the placement of word balloons to the best way to pitch your story to potential publishers. And, what's great about it, is that it really hammers these lessons home." —**Bryan Talbot**, writer/artist **Grandville, The Red Virgin and the Vision of Utopia, Alice In Sunderland, The Tale of One Bad Rat**

Made in the USA
Middletown, DE
05 August 2023

35838616R10117